DISCOVER DRAWING SERIES

Draw Real People!

Lee Hammond

NORTH LIGHT BOOKS

ABOUT THE AUTHOR

Polly "Lee" Hammond is an illustrator and art instructor now living in Portland, Oregon. She specializes in portrait drawing, but practices, teaches and enjoys all subjects and art mediums.

She was raised and educated in Lincoln, Nebraska. She built her career in illustration and art instruction in the Kansas City area, and has lived all over the United States.

She is now concentrating on a career in seminar instruction in a variety of art techniques, art product demonstrations, and writing more art instructional books. She is also expanding her writing into short stories and children's books, which she also illustrates.

"Lee" is the mother of three children, Shelly, LeAnne and Christopher. She also has a granddaughter, Taylor Marie.

NORTH LIGHT BOOKS

An imprint of Penguin Random House LLC

penguinrandomhouse.com

ISBN 978-0-89134-657-9

Printed In the United States of America

Edited by Julie Wesling Whaley
Interior and cover designed by Brian Roeth

METRIC CONVERSION CHART		
TO CONVERT	**TO**	**MULTIPLY BY**
Inches	Centimeters	2.54
Centimeters	Inches	0.4
Feet	Centimeters	30.5
Centimeters	Feet	0.03
Yards	Meters	0.9
Meters	Yards	1.1
Sq. Inches	Sq. Centimeters	6.45
Sq. Centimeters	Sq. Inches	0.16
Sq. Feet	Sq. Meters	0.09
Sq. Meters	Sq. Feet	10.8
Sq. Yards	Sq. Meters	0.8
Sq. Meters	Sq. Yards	1.2
Pounds	Kilograms	0.45
Kilograms	Pounds	2.2
Ounces	Grams	28.4
Grams	Ounces	0.04

INTRODUCTION BY LEE HAMMOND

It is amazing to me how quickly time flies. Maybe it is just the artist in me. When you do what you absolutely love, your clock seems to move quicker than everyone else's. It seems like yesterday that I had the idea for *Draw Real People*. Now, here we are, celebrating its 15 year anniversary. Amazing!

As I look through the book it still makes me smile. I have had the good fortune of receiving hundreds of fan letters regarding this book. It is an awesome feeling knowing that I have been able to mentor so many. To see my work influence people all over the world, and change the lives of aspiring artists in such a profound way, is a feeling that is hard to describe. It truly makes my life worthwhile.

If you are reading this book, you have placed your trust in me to guide you. It is my pleasure to share these techniques with you—I know what it's like to be in your shoes wanting to become an artist.

I am self taught, so the methods in this book have come from years of trial and error. Take the projects one at a time and in the order they are presented. You will be amazed at your progress.

With continued practice and determination you will develop the techniques required to succeed as an artist. Don't be afraid to add your own personal flare—we are all different, and by nature you will create a unique stye. Most of all, just have fun. After all, that is why we draw.

Thanks for being a fan!

DEDICATION

This book is a heartfelt gift to all of my students, past, present and future. Without you all, this wouldn't mean a thing. You are so much more to me than art students. Every one of you is a true friend and a never-ending source of inspiration. Thank you so very much for your enthusiasm and encouragement.

ACKNOWLEDGMENTS

A *huge* amount of thanks and appreciation must go to the wonderful people at North Light Books, especially David Lewis, Julie Whaley, Greg Albert, Kathy Kipp and Budge Wallis, who are always there when I need them. What a wonderful bunch of people you are, and how fortunate I am to be able to work with you! The pleasure is truly all mine.

CONTENTS

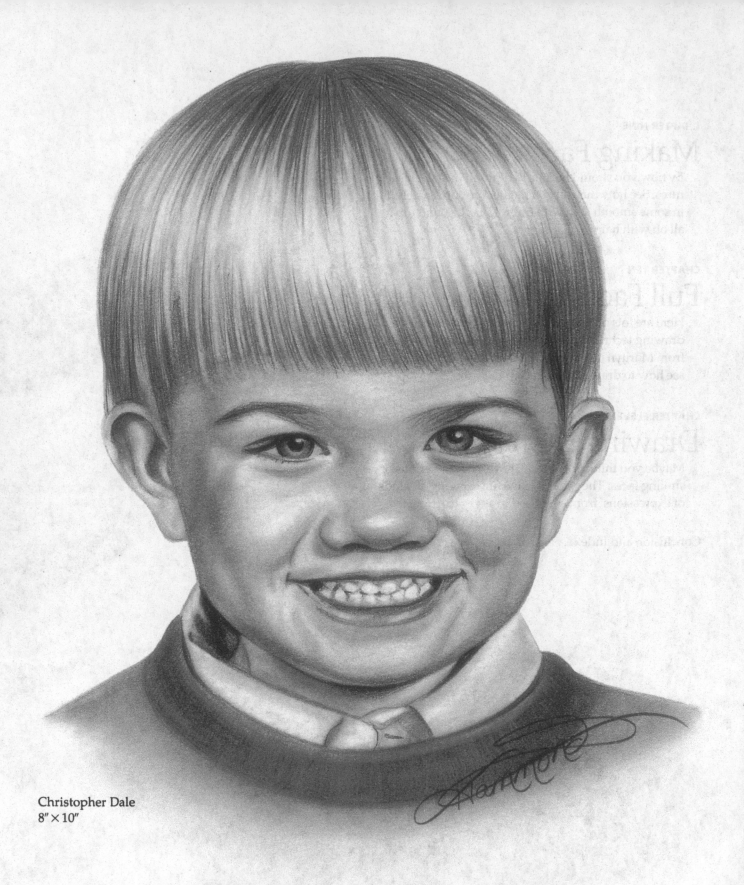

Christopher Dale
8" × 10"

CHAPTER ONE
YOU CAN DO IT!

Draw Real People! is a drawing guide for anyone who wants to create realism in their artwork. After working with beginning artists of all ages, for many years, I have found that the most common stumbling block is not "What should I draw?" but, "How do I make what I draw look real?"

You *can* make your drawings look real. But first you must learn to change the way you "see" things. You have to change the way you look at your subject matter. I know it probably sounds difficult, but it isn't as hard as it sounds. The key is seeing everything you draw as nothing but large and small shapes, all connected together, much like those of a puzzle.

If you are an aspiring artist, the information in this book will arm you with everything you need to know to teach *yourself* how to draw realistically. The principles apply not only to "portraits," but to all subject matter you may attempt to draw in the future.

Practice is the true secret to self-instruction, and each exercise in this book will help you commit certain drawing principles to memory, literally changing the way you "see" things. This is lifelong information. It is not faddish or trendy. It was there for the Old Masters, and it will be there for as long as people study art. If you are a young person, you will have a true advantage by studying this information at an early age. If you are an experienced artist, you will be able to verify what you've practiced all along, and reach even better results than you've ever had before.

By purchasing this book, you receive a gift—a gift of now knowing how to become a better artist, and what to do to grow and see improvements on a daily basis. With dedication and lots of practice, you, too, can *make it look real*!

Getting the Most out of the Projects

Your ability to make your drawings as polished as the ones in the book may take some time to develop. Don't worry! The improvements you will see *immediately* in your work will inspire you. Your drawings may not look like mine right away, but they will be more realistic than anything you have done before, and that alone will keep you trying!

Some of these concepts may be new to you. It will be strange, but exciting to make your drawings look real for the first time. I have seen the excitement in my students as they apply these techniques to their drawings for the first time. This is a book to grow with. After reviewing the student work in the book, some of which was done at a very young age, you will see that you, too, can have wonderful results. It is something to work for, a goal. And it can be achieved with some regular practice and determination.

Practice is the key element to success. Practice, practice and more practice. Suggested assignments and extra projects are provided to keep the information fresh and your enthusiasm high. Have fun!

It looks hard, but I'll prove to you that it isn't as hard as it looks. If you can do this simple shading, you can improve your drawing and make it look real!

WHAT MAKES A GOOD PORTRAIT?

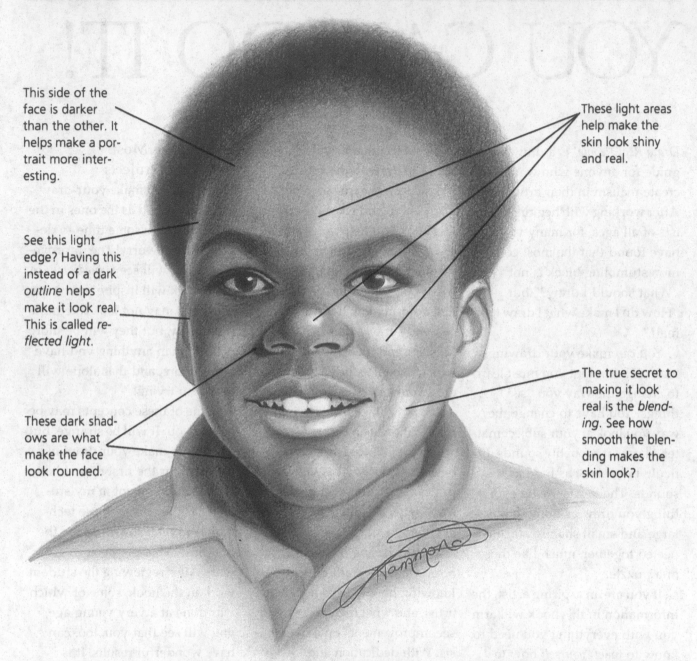

This side of the face is darker than the other. It helps make a portrait more interesting.

See this light edge? Having this instead of a dark *outline* helps make it look real. This is called *reflected light*.

These dark shadows are what make the face look rounded.

These light areas help make the skin look shiny and real.

The true secret to making it look real is the *blending*. See how smooth the blending makes the skin look?

What makes a good portrait? It is more than just how a person looks. It has a lot to do with the "lighting" or *contrasts*. (Contrast is very light areas showing up against very dark areas.)

In this example, I have pointed out certain things to look for when choosing the picture you will be drawing from. Your artwork will be only as good as the photo you have selected.

Look for photographs that have one dark side and one light side. This gives the artwork more interest and gives you shadows to draw. Front lighting, which lights up the whole face, can be nice too, if there are plenty of dark areas next to and below the face. Contrast is very important.

Note: This is a fun face to draw! After completing the assignments in the book, come back to this and draw it for practice.

BEFORE AND AFTER

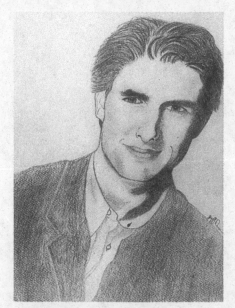

Tom Cruise, first attempt
Artist: Jeff Doran, age 21

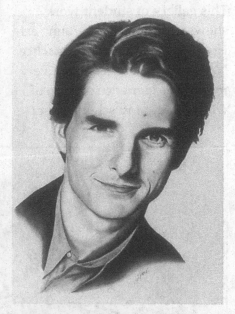

Tom Cruise, revised drawing
Artist: Jeff Doran

These are examples of the kinds of improvements you can expect in your own artwork after learning the principles in this book. This drawing of Tom Cruise is really more of a sketch. Both of the artists' drawings are good. Although he *did* get some shading in the first one, the second drawing shows more realism.

The second example looks more finished, like a portrait. See how the blended approach has helped make it look real?

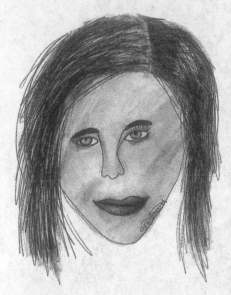

Drawing from a magazine ad, first attempt
Artist: Shannon Wimsett, age 12

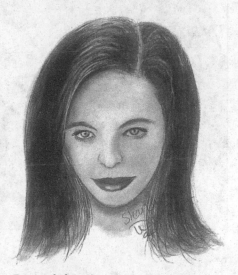

Revised drawing
Artist: Shannon Wimsett

This drawing was what a twelve-year-old student of mine did from a magazine picture. See how all of the facial features have an outline drawn around them? This is what most beginners do. However, nothing in reality has hard lines around it, and anything drawn that way will look more like a cartoon than realistic. I'll show you how to use shading instead of lines to make it look real.

The second drawing looks much, much better. Where the hair in the first drawing looked scribbled and messy, this hair looks softer and smoother. Where the blending on the first attempt looked smudged and uneven, this blending makes the skin look smooth and even. The nose and mouth aren't outlined anymore. The whole appearance is a lot more refined.

Note: The amount of improvement in your work will depend on the amount of practice work you do. Both of these artists did a lot of practice work, and there are about two to three weeks between their befores and afters. They took the time to study the information presented in this book.

STUDENT WORK

This gallery of student work shows what some very young artists were able to do with practice. None of these students had very much art experience outside of what is taught in school. All of them wanted to make it look real!

It is inspirational to think of what their artwork will look like in a few years. They sure have a head start on a wonderful talent and a life filled with art.

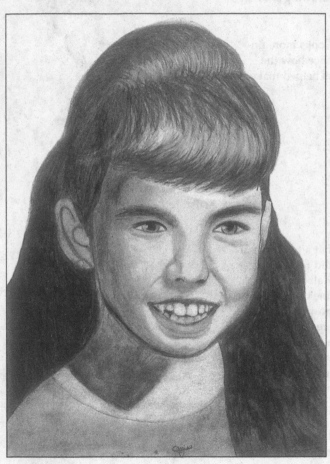

"Cami"
9" × 12"
Artist: Cami Webster, age 10

"Kari"
11" × 14"
Artist: Kari Gruber, age 11

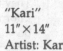

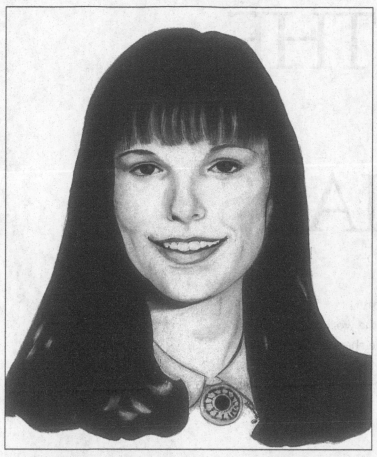

11" × 14"
Artist: Sarah Burkhardt, age 13

"Grampa"
10" × 12"
Artist: Lisa Gerard, age 13

CHAPTER TWO

USING THE RIGHT MATERIALS

When doodling or sketching on your own, any drawing materials will work. Crayons, markers and colored pencils are fun, and the type of paper you use doesn't really matter.

But what do you use when you want to draw like a professional? You don't have to spend a lot of money to have quality materials, but you do have to have the right things! Here's what I recommend.

Drawing Paper

You need a smooth, heavy paper called Bristol. It comes in pads and is terrific for shading and blending.

Pencils

I always use a "mechanical pencil." It has small sticks of lead in it, and you click the end of the pencil to push the lead out the tip. You put twelve pieces of lead in at once and they last a long time without ever having to sharpen your pencil. (Use 2B lead, because it's nice and soft and dark.)

Tortillions

What in the world is a tortillion? It is a cone-shaped thing made out of paper that you use instead of your finger for blending and shading. This is the "secret" to my whole technique.

Kneaded Eraser

This is a gummy, soft, squishy eraser that looks and feels like clay. You can mold it into lots of different shapes, and you can get neat effects by using it in your artwork.

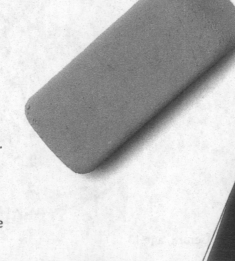

Typewriter Erasers

These erasers look like pencils with a stiff brush on the end. They are good for erasing stubborn stuff off your paper and for making "edges" nice and sharp in your drawings.

Pink Erasers

This is an all-purpose eraser, just like the one we used in school. Always have one handy.

A note about the different erasers. You will use the kneaded eraser the most. The pink eraser is for large areas, or for removing the graph lines you will be using. The typewriter eraser is used for "tight" areas, or for cleaning up edges. It is also good for dark lines that won't come up with the other erasers.

Ruler

To draw things in their right shape and size, we will graph and measure. There are many differ-

ent types of rulers, so find one that feels comfortable to you.

Report Covers

These are shiny plastic sheets that are made for holding papers together. We will be making graph overlays with them.

Permanent Black Marker

This is what you need for drawing lines on your report covers.

Circle Templates (Stencil)

This is to help you draw perfect circles, which is very important when you are drawing eyes.

Magazines

This is your best source for practice material! Tear out pictures you may want to draw and keep them in a file or large envelope. I collect pictures of *everything* and separate them into different categories.

Coloring Books

Practice *drawing* the pictures, instead of coloring them in.

CHAPTER THREE

SHAPES

When drawing, it really doesn't matter what the subject is, the same principles will apply. You should tackle your drawing the same way whether you are drawing a face or a spaceship.

First, always see the thing you are drawing as a *shape*. What does it look like around the outside edges? How big is it? What about the shapes inside? How do they all fit together?

Next, how dark or light are all of those shapes? Are they black, or are they white? Are they somewhere in between? If you can always remember *shapes*, *darks* and *lights* as you draw, you can *make it look real*!

Here are some fun exercises to help you train your eye to see shapes, darks and lights. Notice that in the graph on the left, each box has a number and a pattern of light and dark shapes inside it. The graph on the right has empty numbered boxes. Draw the black and white shapes that you see in the boxes on the left, in the corresponding numbered boxes on the right. (Example: Draw the shapes with the number 62 in it, in the empty number 62 box.) Draw the shapes as accurately as possible. Draw them just as they appear inside their boxes. Don't try to figure out what you are drawing. Be sure to make them black and white.

When you are finished, turn your work upside down and look at the image you have created. You have just proved to yourself that you can indeed draw! (If you have a hard time seeing what it is you just drew, here's a trick. *Squint* your eyes when looking at it. This blurs your vision and makes the lights and darks stand out more.)

In not knowing what you were drawing, you just saw funny shapes, so it was easy! If you had known what you were creating from the start, it would have been a lot harder, because we always seem to draw from memory.

When you know what you are drawing, you do not look at your subject as carefully. Your mind, or memory, is telling you what you "know" the subject looks like. So, instead of keeping your eye on your subject matter as you draw, you take a look, and then turn to your drawing paper and draw from memory. To make it look real, you have to keep your eyes constantly going back and forth from your subject to your drawing paper. This will train your eye, your hand and your mind to work together. Your work will be much more accurate.

Remember this! Everything you draw from now on *must* be seen as puzzle-piece shapes, all connecting together to create a picture. All you need to decide is: What shape are they? Are they light, medium or dark? Later on, you will see how this applies to facial features.

EASY BAR GRAPH

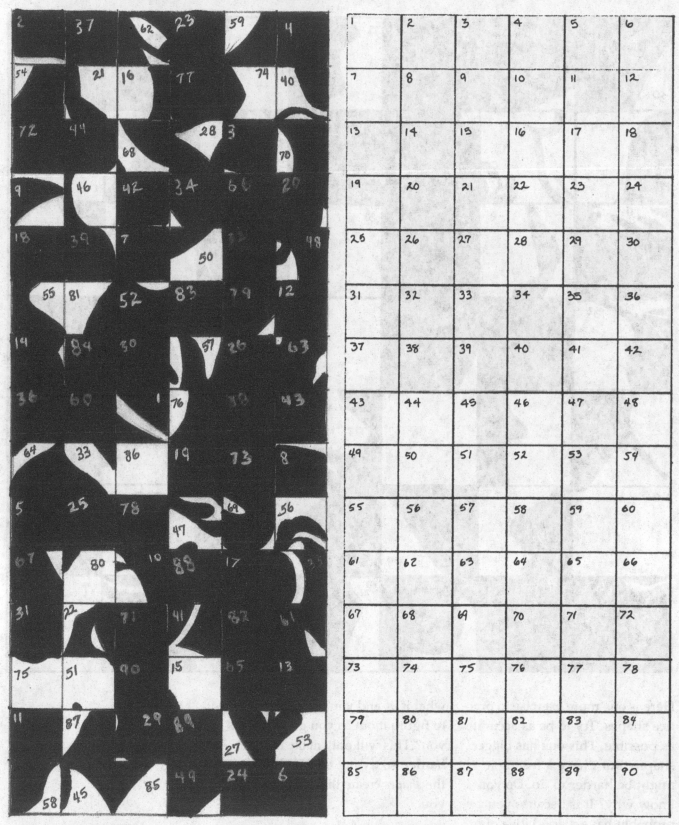

1	2	3	4	5	6
7	8	9	10	11	12
13	14	15	16	17	18
19	20	21	22	23	24
25	26	27	28	29	30
31	32	33	34	35	36
37	38	39	40	41	42
43	44	45	46	47	48
49	50	51	52	53	54
55	56	57	58	59	60
61	62	63	64	65	66
67	68	69	70	71	72
73	74	75	76	77	78
79	80	81	82	83	84
85	86	87	88	89	90

Draw these shapes with pencil first. This way you can make corrections. To help you see the image better when you are done, fill in the dark shapes with a black marker.

BAR GRAPH CHALLENGE

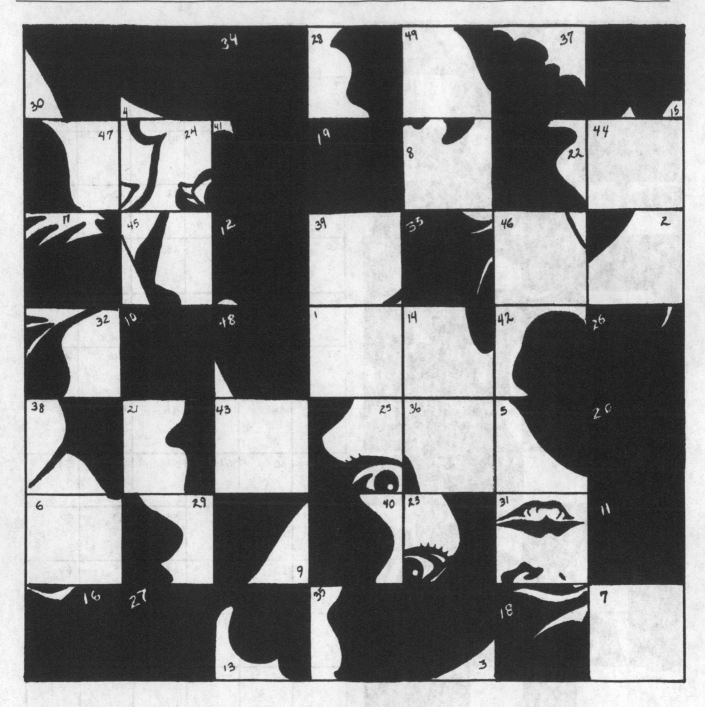

Here is one more exercise to practice shapes. Try to be as accurate as possible. This one has bigger shapes, but I have a feeling it might be harder to do. Do you know why? It is because you probably have a good idea of what it is, and you're going to try to figure it out as you go, aren't you? This will only make it harder, so try not to, OK? Just let the *shapes* create the image for you.

49	48	47	46	45	44	43
42	41	40	39	38	37	36
35	34	33	32	31	30	29
28	27	26	25	24	23	22
21	20	19	18	17	16	15
14	13	12	11	10	9	8
7	6	5	4	3	2	1

Note: If you do not want to draw in the book, photocopy this page.

GRAPHING A DRAWING

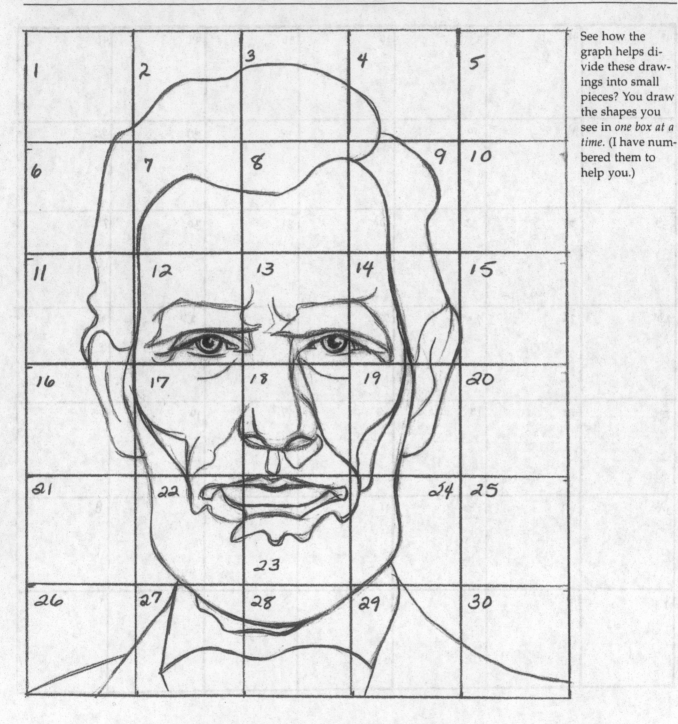

See how the graph helps divide these drawings into small pieces? You draw the shapes you see in *one box at a time.* (I have numbered them to help you.)

Here are more fun exercises for you to do. This is similar to the line drawings you would find in a coloring book. Try your graphing skills on this. I have started the line drawing for you. You finish it! (Again, if you do not want to draw in the book, photocopy this page.)

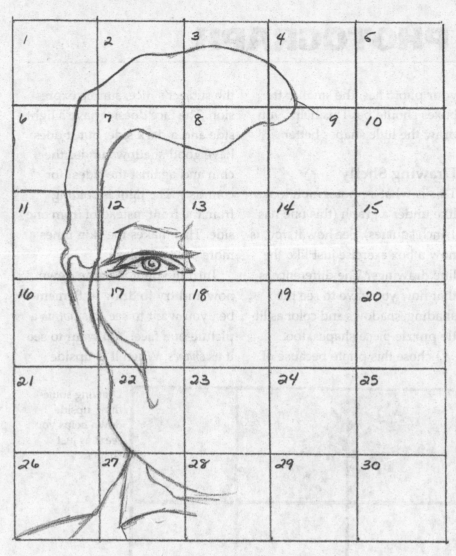

I started the line drawing for you. See how these shapes can be seen in the same box on the other graph? You finish it!

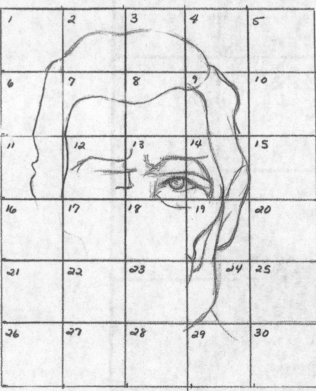

Enlarging and Reducing

Graphs can help you enlarge or reduce what you are drawing. For instance, if you want what you are drawing to be smaller than your photo, place a 1-inch graph over the photo and draw a ½-inch graph on your drawing paper. By drawing the shapes you see, just as they fit in their box, your drawing will end up half as big as the photo. To enlarge, make the boxes on your drawing paper bigger than the ones on the photo.

GRAPHING A PHOTOGRAPH

To help you draw from photographs, you can create your own graph overlays. They are easy to make by drawing boxes on clear acetate report covers with a permanent marker. Use a ruler to make the lines very straight so the boxes are perfect squares. Once they are done, slip a photo underneath to turn your photo into a graph exercise.

Make two graphs, one with 1-inch squares and another with ½-inch squares. The more details your photo has, the smaller the boxes should be. This helps you draw the little shapes better.

Drawing Shelly
This is what a photograph looks like under a graph (this one has 1-inch squares). See how it, too, is now a box exercise just like the line drawings? The difference is that now you have to see the shading, shadows and color as little puzzle-piece shapes, too.

I chose this photo because of the subject's nice, simple expression. The face doesn't have a light side and a dark side, but it does have good shadows under the chin and against the sides (for contrast). The light is coming from the front instead of from one side. This makes the skin tones more even in color.

Turn the photo upside down now and try to draw it. Remember, you want to see this *not* as a picture of a face. You want to see it as *shapes*. When it is upside

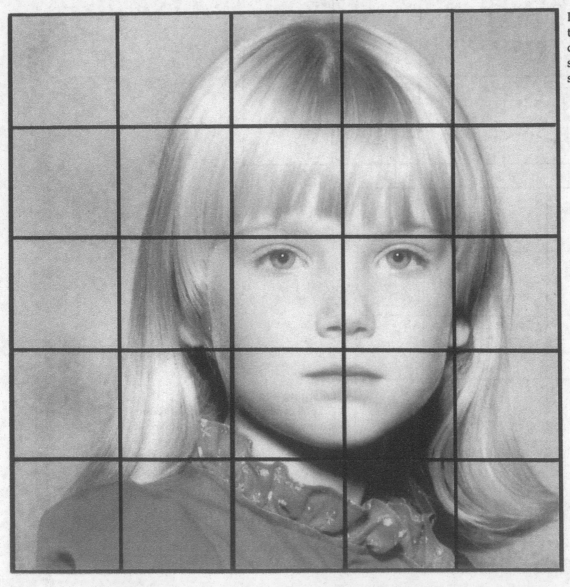

Drawing something upside down helps you see it as just shapes.

down, it prevents you from looking at it as a person's face and drawing from your memory of what a person looks like.

Draw a graph on your drawing paper. Be sure that the pencil lines are drawn *extremely light*. They will be erased later. You will need a 1-inch graph, with five boxes across and five boxes down. Be sure that your squares are perfectly "square." If their measurements are inaccurate, the size of your shapes will be incorrect. This will make your drawing look "off" in it's likeness. Only a very accurate line drawing will make your work look real.

Before you begin drawing, study the shapes contained within each square over the photograph. Begin by drawing those shapes, *one box at a time*. Sketch your shapes lightly at first, making corrections as you go. Remember that these will only be guidelines for placement and will be drawn over or erased as your work develops with shading.

I have finished drawing the shapes in my graph. This is what is called an "accurate line drawing." This means that all of your shapes are now drawn in their proper size, shape and placement. All the facial features are now in place, thanks to the graph and your skills at seeing shapes.

Note: We will be drawing this portrait later on. Keep this line drawing in a safe place; we will come back to it later.

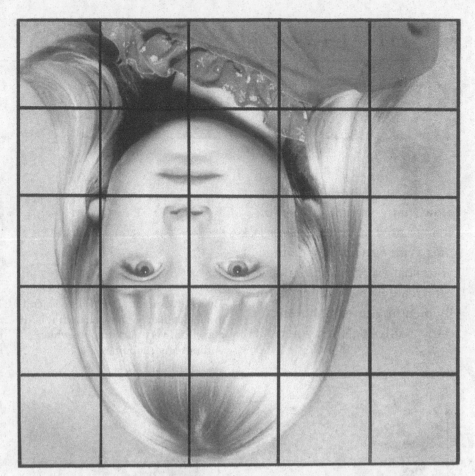

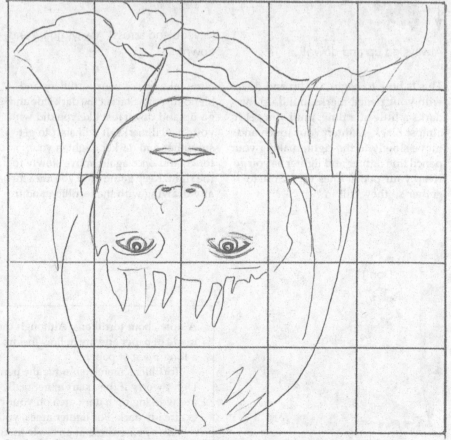

See how this now looks like the line drawings of Abe Lincoln on page 18?

SHADING

Now that you are an expert on shapes, how do you *make them look real*? With *blending*! By giving your shapes light and darks, you can create roundness, or "form." By blending these lights and darks softly together, you create *realism*.

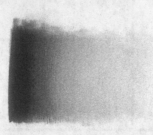

This is an example of what good blending looks like. See how smooth it is? It goes from very dark to pure white, without any choppiness.

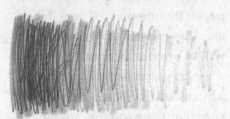

This is an example of poor blending and what can go wrong. It looks scribbled. There is no control of the pencil lines and it doesn't blend out at all.

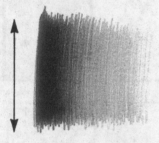

Always go up and down!

This is how to begin. Go up and down with your pencil marks, build up the darks a little at a time, until you get it almost black. Lighten your touch and move slowly to the right, making your pencil line lighter and lighter as you go. Keep your pencil lines very close together so they "fill in."

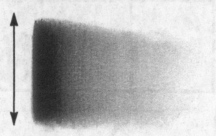

Never blend across! Always go up and down!

Now take one of your tortillions and blend this out. Start at the dark side and go up and down just like you did with your pencil marks. It will start to get smoother and darker. Lighten your touch and once again, move slowly to the right. Keep going until you are actually drawing with the tortillion and it

fades to nothing. If it starts to get shorter and looks like a sideways tornado, don't worry. That is normal!

Squint your eyes and look at your work. If you see little light areas or spots, take your pencil and gently fill them in to help it look smoother. If you see dark areas, take your kneaded eraser between your thumb and fingers and roll it into a point. Lightly "lift" the dark areas out, with the eraser's point.

Keep practicing the blendings until you can do one that is very even and smooth. Don't move on in the book, until you feel confident.

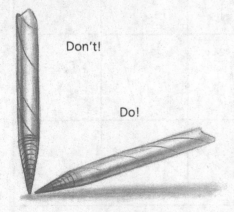

Don't!

Do!

A note about tortillions: Although they may look like pencils, they are just made of paper and are hollow inside. If you unravel one, you'll end up with a long piece of paper.

Tortillions merely smudge the pencil lines that are already on the paper. Don't worry if they start to get really dirty. Save them! Later on, when you are working on a dark area on your drawing, you can use a tortillion that is already dark. For lighter areas, you can use a fresh one.

Always use these at an angle to keep from flattening the tip.

SHADING A SPHERE

There are five "elements" that go into shading. Each of these elements has a tone that matches the five-box value scale. Here is an explanation of each of them and where you can see them on the sphere.

1. **BLACK** This can be seen under the ball where no light can reach. It is called a *cast shadow*.

2. **DARK GRAY** This is the *shadow* on the ball. It is always on the opposite side of where the light is coming from. On this ball, the light is coming from the upper front. The shadow is seen around the lower side. See how the shadow makes the ball look round, by curving around it?

3. **MEDIUM GRAY** This is called a *halftone*, because it isn't light and it isn't dark. It is seen halfway between the light area and the dark area.

4. **LIGHT GRAY** This is the hardest element to see, but it is probably the most important one to have in your artwork. It is called *reflected light*. It is light that bounces up onto the ball from the table it's sitting on, and all of the light behind it. It can be found anytime you have an *edge*, or *rim*. It separates shadows from cast shadows.

5. **WHITE** This is the *full light* area. It is where the light is the strongest. It is where the white of the paper is left exposed.

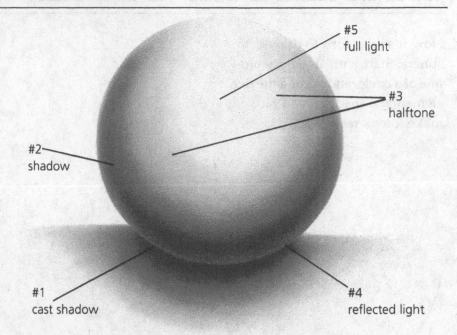

This is what good shading looks like. Without it, this would be just an empty circle. With shading, it becomes dimensional and looks like a ball. On this sphere, the light is coming from the front.

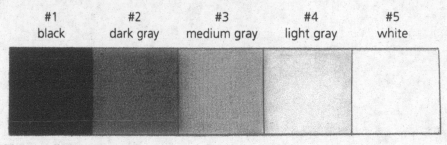

#1 black	#2 dark gray	#3 medium gray	#4 light gray	#5 white

This is called a value scale.

These dark areas should be "lifted" with the pointed edge of a kneaded eraser.

Light spots can be gently "filled" with the pencil.

When you look at these examples of blending, squint your eyes! Can you see the dark areas that don't belong there? Can you see the light spots? These can be corrected with your pencil and eraser.

SHADING STEP BY STEP

Now it's your turn to draw a sphere. Start with an empty outline of a circle, and adding the five elements of shading, you can make it look real!

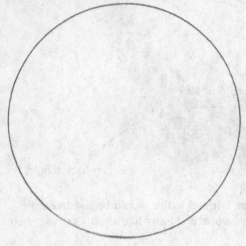

An empty circle.

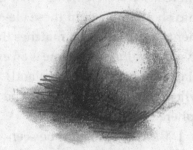

This is what some beginning attempts can look like. Study carefully and you can see what *not* to do.

DON'T outline your circle. The beginning outline is always erased when you are done.
 DON'T use scribble lines. They can't be blended out. Always keep your marks very close together.
 DON'T get too dark too fast. This looks like a dark mess—there is no consistency and direction to the pencil lines. Always go "with" the shape of the object.
 DON'T lose the reflected light on the edge. There is nothing here to separate the shadow from the cast shadow.
 DON'T let your blending get uneven and out of control. Stay within the lines and let it fade gradually from dark to light. This looks too dark and it looks like it has a hole in it. You can't even tell where the light is coming from.

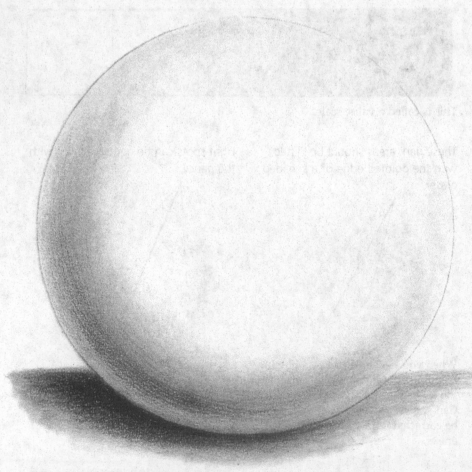

A shaded ball, or "sphere." When blending, use your "dirty" tortillions for dark areas, but *always* use a clean one when going into a light area! Keep your tortillions separate and always have a fresh supply on hand.

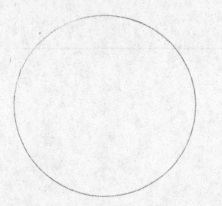

Step 1
Use something round to trace a perfect circle.

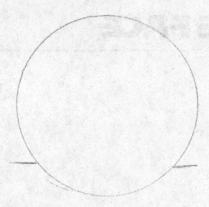

Step 2
With simple lines, create a tabletop.

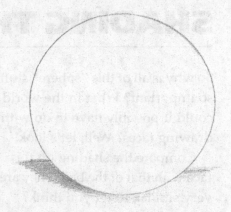

Step 3
Start to draw a *cast shadow*. The light on this ball is coming from the upper right, so the cast shadow is found on the lower left. Be sure to create a crisp edge underneath the circle. Don't go inside the line—if you do, the ball won't look round.

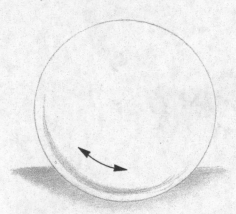

Step 4
Blend out your cast shadow, keeping it smooth. It gets lighter as it gets farther away from the ball. Now apply the *shadow* to the ball itself. It must be rounded like the ball to create "form." Follow the arrows when applying your pencil lines. Remember that the cast shadow is darker (#1) and the shadow is a #2. Don't bring the shadow clear to the edge. Leave room for the *reflected light*.

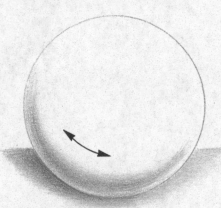

Step 5
Blend out your shadow with a tortillion. Go the same direction you did when applying your pencil. Lighten your touch as it goes up into the lighter area. This will create your *halftone* (#3).

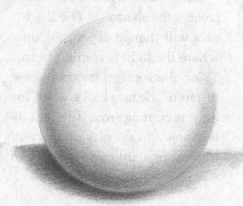

Step 6
Finish it off with more blending. Soften the lower edge where the *reflected light* is, because reflected light is not bright white, but is #4 on your scale. Leave the white of the paper for the brightest area, but be sure to use your tortillion to gently soften the gray into it so it doesn't look harsh. It should be a gradual fade. If anything still looks choppy when you squint, you can repair it with your pencil and kneaded eraser.

The final touch should be the removal of the outline around the ball. You want to create an *edge* where the tones quit—you *do not* want an outline. Anything with an outline will look flat and cartoony.

#1 black	#2 dark gray	#3 medium gray	#4 light gray	#5 white

SHADING THE FACE

So why is all of this "sphere" stuff so important? What in the world could it possibly have to do with drawing faces? Well, let's look!

Compare the shading on this face with that of the ball. They are very similar, don't you think? Faces and heads are very round, so all of the same principles of shading apply. It is the lighting and shadows that make this face look real. If you removed the eyes, nose and mouth, you'd have a sphere!

Remember, it is the *light* that creates the shadows. The shadows will change depending on where the light is coming from. These three examples show how different the face looks when the light is coming from different directions. Always pick photos with interesting lighting to work from.

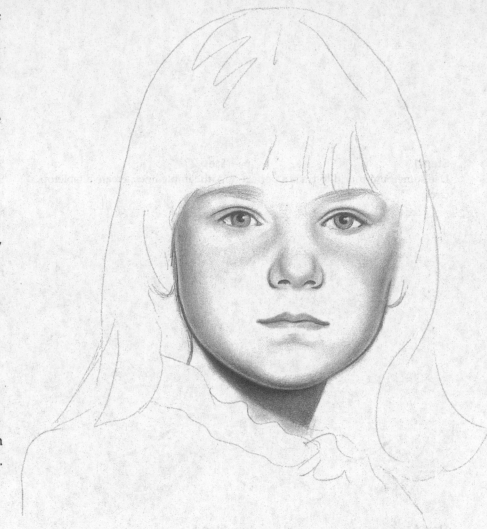

Look for the five elements of shading on this face. Without them, the face would not have its rounded appearance.

A solid understanding of the sphere will help you draw rounded objects realistically!

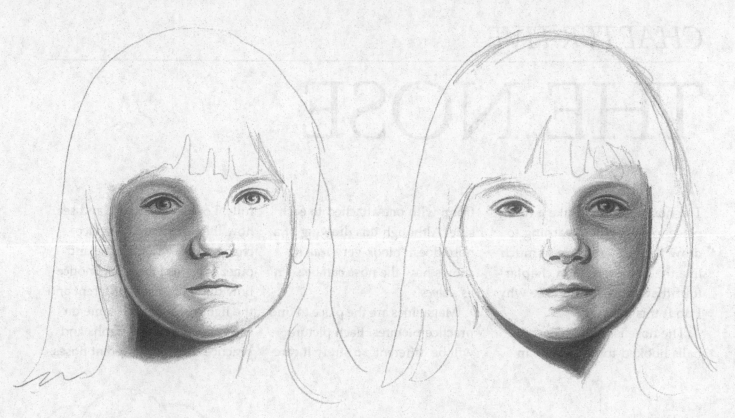

Light coming from the right.

Light coming from the left.

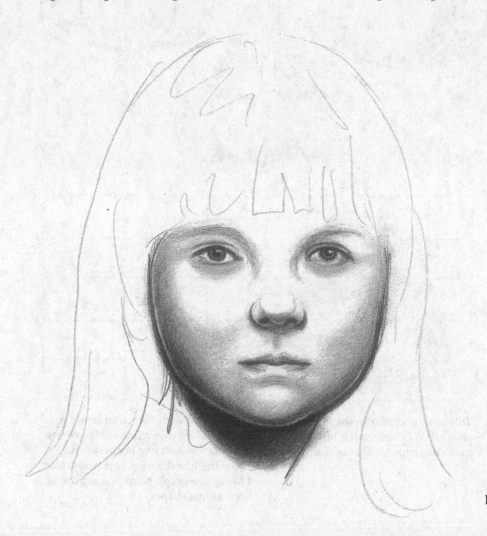

Light coming from the upper front.

THE NOSE

The nose may seem like a funny place to start when learning to draw the face, but it is so much like the ball exercise in chapter four that you will soon see why I do it this way.

The nose is really like three balls hooked together, one in front, with one attached to each side. Although this drawing of a nose doesn't look very *real*, it shows how the nose can be seen as *shapes*.

Magazines are the place to find practice pictures. Each picture will be different, so study it carefully. Look at each pose and see how the direction of the face changes the way the nose and other features look. Also, notice how the skin tone is different and the lighting is not the same on each one. Use your graphs and practice drawing different noses.

This is a very simple line drawing of a nose, merely showing the nose's overall shape. It is important to see all the various little shapes that make up this drawing.

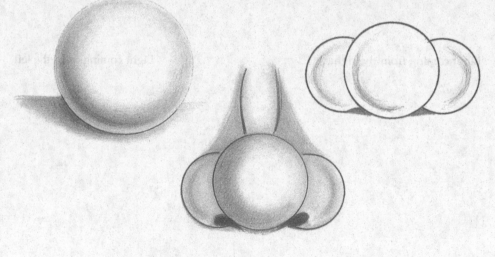

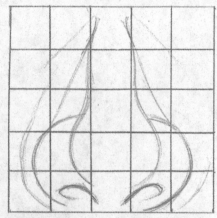

All of these shapes shown here fit together to create the line drawing above. See how simple they are? Drawing each shape by itself is easy, but when we put them all together, it gets harder. Why is that? It's because we then recognize the overall shape as a nose and our minds tell us that drawing noses is hard!

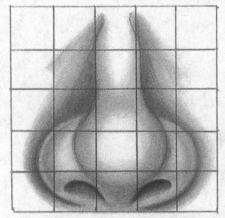

This nose is similar in shape to the one above, but I changed it a little bit to make its shape look more real.

Make a grid with ½-inch squares on your drawing paper. It should have five boxes across and five boxes down. Draw the line drawing of the nose like I have. The graph helps you see the nose as just shapes.

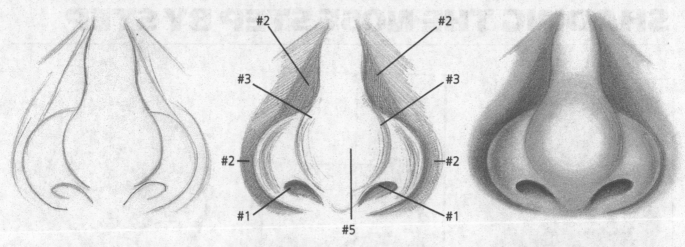

Once you are sure your line drawing looks right and is accurate in its shape, erase your graph lines.

Start by applying dark and medium tones with your pencil. See how the tones are numbered to match the five-box value scale (see page 23)? You must see the tones as *shapes*, too.

Blending creates your halftones (#3) and light gray areas (#4). Be sure to bend *around* the curves as you did with the sphere.

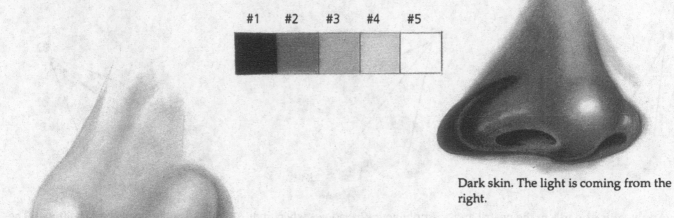

#1	#2	#3	#4	#5

Pale skin. The light is coming from the left.

Dark skin. The light is coming from the right.

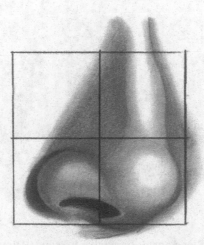

Medium skin. The light is coming from the front.

SHADING THE NOSE STEP BY STEP

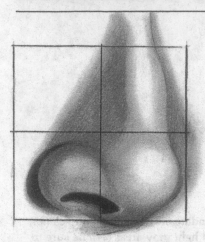

Let's use this one for a study in shading a nose step by step.

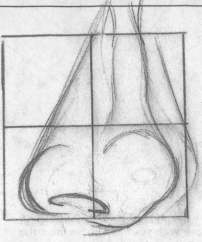

Draw a 1-inch graph (four boxes). Complete the line drawing. Make sure it is accurate.

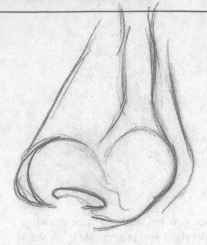

Erase your graph.

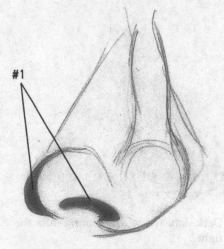

Apply your #1 darks in the nostril and cast shadow on the left side.

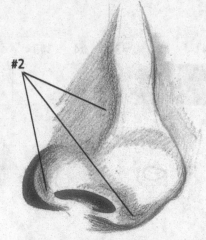

Apply your #2 shadows where indicated.

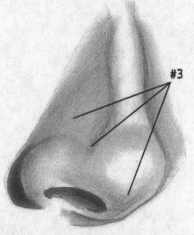

Blend out to create the #3 halftones. The #2 shadows are now softened.

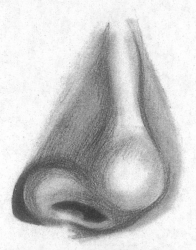

We need to make the skin a little darker, so reapply your shadows.

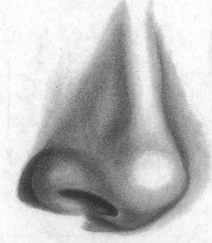

Blend again. Remember to *squint*. If you see little light areas, fill them in. If you see little dark areas, lift them out gently with your kneaded eraser.

#1 #2 #3 #4 #5

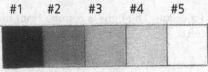

THE MOUTH

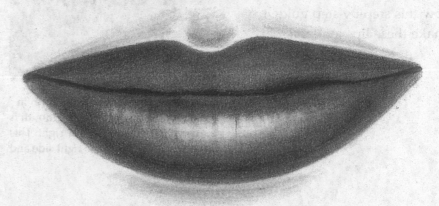

When drawing a mouth, remember these guidelines:

1. The top lip is usually darker than the bottom one.
2. The bottom lip has highlights.
3. There are light shadows all around the mouth.
4. *Never* draw an outline around the mouth.

See the bright highlight? It makes this mouth look moist.

The top shape of the upper lip looks kind of like a squashed *M*. The little space between the nose and the mouth resembles a *U*.

The line between the lips is very irregular. In some places it looks thick and fat, and in others it seems very thin. The corners of the mouth resemble a comma, or tear shape. This is called the "pit." This is a very important thing to include in your drawing, because it makes the mouth look like it goes *in*, not flat and pasted on the front of the face.

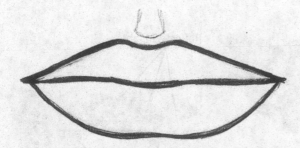

Never draw a hard line all around the lips like this! These lips look like a cartoon. Women's lips will look darker, and sometimes it will look like there is an outline due to makeup, but be sure to soften it out to an "edge," not a bold line.

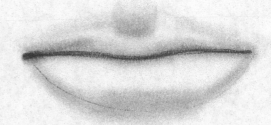

Sometimes men's lips are very light in color. These lips were drawn not with lines, but with shadows above and below. Except for the line between the lips, I drew this mouth with a used tortillion.

DRAWING THE CLOSED MOUTH STEP BY STEP

It is easier to draw the mouth with the lips together so you don't have to deal with the teeth. Follow this step-by-step guide to make these lips look *real*.

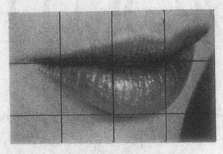

Study the placement of this mouth inside the boxes. Notice that the mouth is somewhat turned, facing the right. This means you see less of the right side and more of the left.

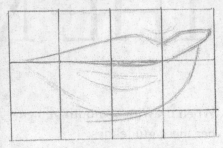

See how the last line of the graph cuts through the center of the upper lip? Your memory will want to draw the mouth with that in the center, not off to the right. Always draw what you *see* in front of you, not what your memory wants you to draw! This is why using a graph is so important. It keeps the shapes where they belong.

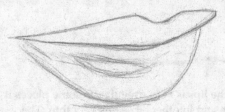

Erase your graph.

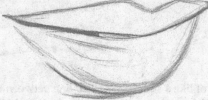

Apply #1 dark to the line in between the lips and where the lips part inside the left corner.

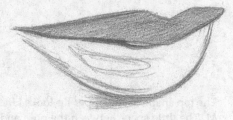

Apply #2 dark gray to the upper lip and below the lower lip.

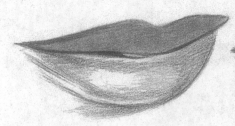

Apply #3 halftone gray to the lower lip, leaving a spot for the highlight. Darken the right side of the lower lip to more of a #2 (refer to photo).

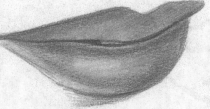

Blend until smooth!

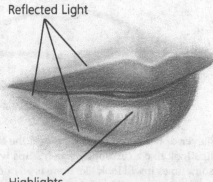

Reflected Light

Highlights

Pull out highlights with the kneaded eraser. Add shading above and below the mouth. Notice the light edge around the lips? This is reflected light.

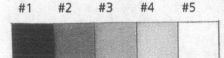

| #1 | #2 | #3 | #4 | #5 |

DRAWING THE OPEN MOUTH STEP BY STEP

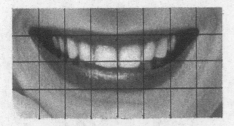

I used a smaller graph with this one. This is helpful for placing the teeth. Each tooth has to be the right size, the right shape, and in the right spot.

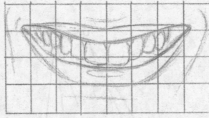

Watch your shapes! (Remember these aren't really teeth after all; they are little shapes that go together to look like a mouth.)

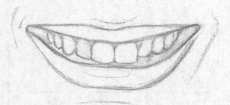

Look at this line drawing. Can you see the little shapes that are *between* the teeth? Can you see the little triangular shapes created by the gums? These shapes will help you get the shape of each tooth. Also, don't ever draw a dark line between each tooth. This makes them look like corn on the cob or piano keys.

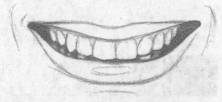

Darken the inside corners of the mouth (#1) and under the teeth. Look for the small shapes of the bottom teeth. Even though they are hard to see, they are important.

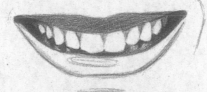

Apply #2 to the upper lip. With a dirty tortillion, put some blending into the gums. Blend below the teeth.

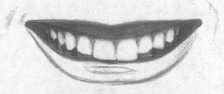

Blend the upper lip until it is smooth.

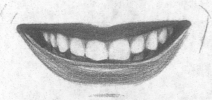

Apply #2 to the lower lip, leaving reflected light around the edge and the highlight in the center.

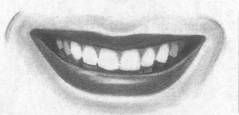

Blend out the lower lip. Don't worry if you go into the highlight area. You can use the kneaded eraser to lighten the highlight, to make it look shiny. Take a dirty tortillion and apply shading around the mouth where you see it.

Note: See how many mouths you can study in magazine pictures. Look at all the various expressions you can find. Practice, practice, practice!

DRAWING THE FEMALE NOSE AND MOUTH TOGETHER

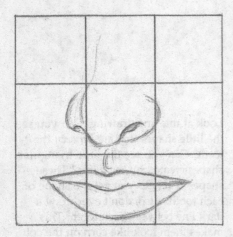

Here's a simple line drawing. Draw a graph and follow the step-by-step instructions.

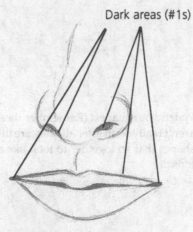

Dark areas (#1s)

Add the dark areas to your line drawing (#1 on the value scale).

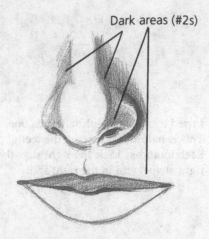

Dark areas (#2s)

Add the gray areas of shadow (#2 on the value scale).

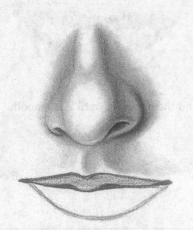

Blend out the entire nose and down to the upper lip. Use #3 on the value scale.

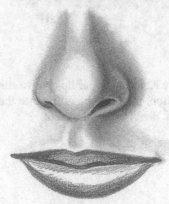

Add more darks (#1s) to the lip areas.

#1 #2 #3 #4 #5

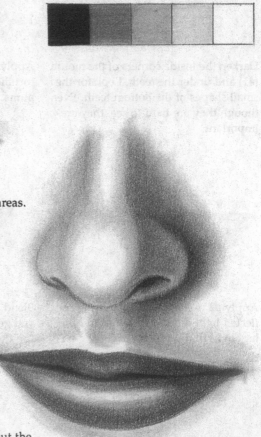

Blend out the lips to finish. Lift out the highlight to make the lip shine.

DRAWING THE MALE NOSE AND MOUTH TOGETHER

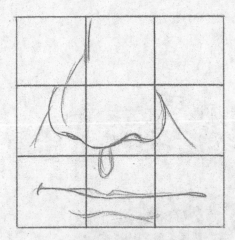

Accurate line drawing.

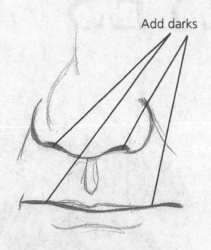

Add darks

Add darks (#1 on the value scale).

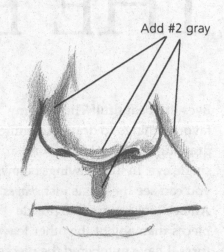

Add #2 gray

Add dark gray (#2 on the value scale).

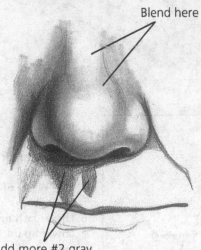

Blend here

Add more #2 gray

Blend the nose to complete; add gray tones (#2) to the upper lip.

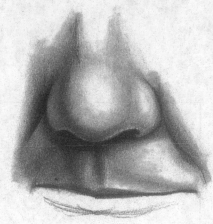

Blend out the upper lip.

#1	#2	#3	#4	#5

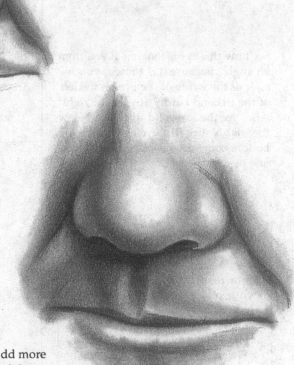

Blend out the lower lip. Then add more gray (#2) under the lip and blend down toward the chin area.

THE EYES

Eyes are beautiful! They are my favorite things to draw. An entire drawing can be made around a single eye. In the drawings below, you can see the eye is just *shapes*. An eye looks more like puzzle pieces than any of the other features. I have numbered the pieces to help you see the various parts that make up the eye.

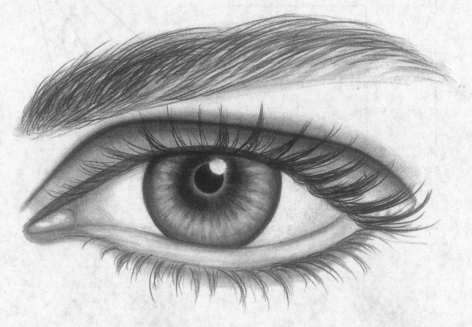

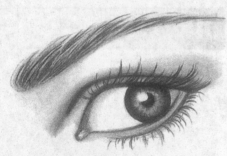

See how this eye is looking at you from an angle? Because it is turned, you see a lot of the white of the eye on the left of the iris and hardly any on the right. Also, see the lower lid thickness below the iris? Notice that eyelashes on the bottom come off the lower line, not the one next to the eye.

Note: You will notice that the "catchlight," or flash, is *half in the pupil* and *half in the iris*. No matter how many catchlights you see in your photo, your drawing will look better if you only use *one in each eye*, and placed in that position. This is the only time I stress "cheating," by *not* drawing what you see. (Artistic license!)

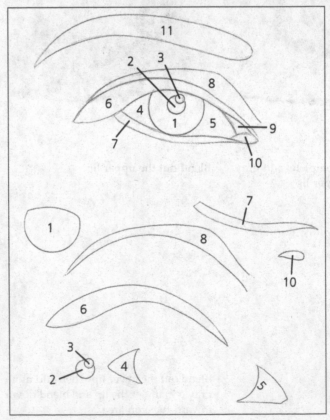

1. Iris
2. Pupil
3. Catchlight (or flash)
4. & 5. White of the eye
6. Upper lash line
7. Lower lip thickness
8. Upper eyelid
9. & 10. Corner eye membrane (tear duct)
11. Eyebrow

All of these shapes can be seen above in the line drawing of the eye. Try very hard not to look at the eye as one difficult shape, but instead as eleven easy shapes.

EYEBROWS AND LASHES

 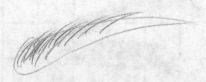

The line on the left looks hard and straight. The line on the right is softer and curved. It was drawn with a *quick* stroke. Flick your wrist and the line will become thinner on the end.

Eyebrows can be large or small, thick or thin. Just draw the overall shape first.

Start to apply little hairs. Look at the direction they are growing in the picture and apply your pencil lines in that direction.

Continue to draw hairs until they start to fill in, and then take your tortillion and blend the whole thing out.

Add hair strokes again, until it gets as dark as you want it.

To soften it a bit, take your kneaded eraser, put it into a point, and with the same quick strokes, lift some light hairs out. It is this finishing touch that really helps make it look real.

Never just fill in the eyebrow with heavy dark pencil lines.

This is better, but the lines still look harsh and too straight.

These lines work. They are curved and tapered at the ends, more like hair really is.

Eyelashes should not be drawn with hard lines either. These lines are much too hard and straight.

This is the way eyelash lines should be drawn, but eyelashes don't grow in single lines like this.

Eyelashes grow in clumps like this. Watch which direction they curve

Don't ever draw a line all around the eye with lower lashes like this.

This is what lower lashes should look like. They come off the bottom of the lower lid thickness and are shorter than the upper lashes. See how some of them are shorter than others? They, too, grow in bunches.

DRAWING THE EYE STEP BY STEP

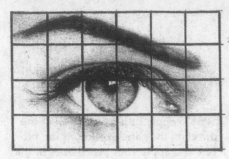

Graph this eye out on your drawing paper.

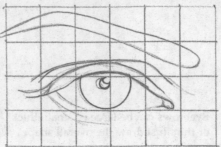

Not only do you need to see the eye as just shapes, you need to see the shapes created with the graph lines. This is where you will use your circle template, or stencil. The iris and the pupil are perfect circles in nature. The reason many drawings of people don't look right is because the eyes aren't drawn with good circles.

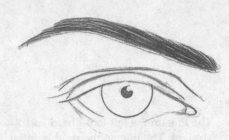

Remove the graph. Lightly draw the circles in the eyes by hand. Then crisp up the circle with the stencil. If you are drawing two eyes, remember to use the same circle for both eyes. The catchlight should be placed half in the pupil and half in the iris.

Start to fill the eyebrow with pencil strokes and darken the pupil.

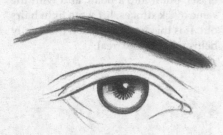

Add some #1 dark around the outside edge of the iris and around the pupil. Blend out the eyebrow.

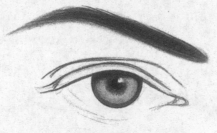

Blend out the iris until it is a #3 halftone. Don't lose your catchlight!

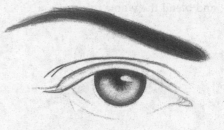

Lift some light out of the iris with your kneaded eraser to make it look shiny and enlarge the catchlight.

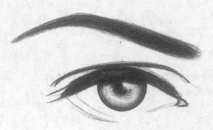

Fill in the lash line #1 and #2. (It is lighter in the middle above the iris.)

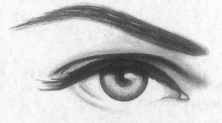

The finishing touches! Blend some tone above the eye. Soften the lower lid thickness. Blend a little into the white of the eye to make the eye look round. Pull some light hairs out of the eyebrows. This eye doesn't have many eyelashes showing, just a few coming off the sides.

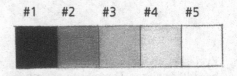

#1 #2 #3 #4 #5

"EYE DO" (AND DON'T!)

Here are some guidelines to remember when drawing the two eyes together:

- The distance between the eyes is equal to one eye width.
- Draw a line from the inside corner of the eyes and you have the width of the nose. (This is a general rule and doesn't always apply to all races.)
- Draw a line down from the center of the eyes and you will usually have the outside corner of the mouth (that is, with no smile).
- Eyes are in the middle of the head! Don't draw them too high. If you measure from the chin to the eyes, you will find the same distance from the eyes to the top of the head.

This is a list of what *not* to do when drawing eyes:

- *Don't* outline the eyes.
- *Don't* make eyelashes hard and straight.
- *Don't* scribble in the eyebrows. Watch those shapes!
- *Don't* draw the iris and pupil round. Use your stencil.
- *Don't* forget the catchlights (these eyes don't have any).
- *Don't* have the eyes looking in two different directions. The two eyes work together.
- *Don't* let your blending get rough and uneven. Remember—smooth and gradual.

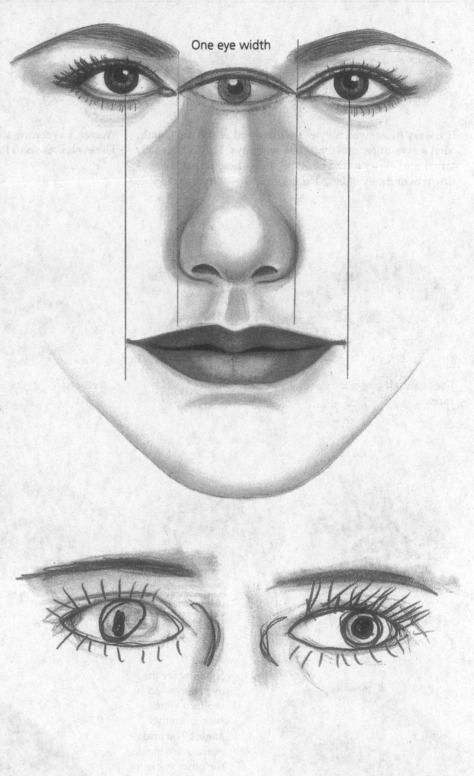

One eye width

EXAMINING EYES

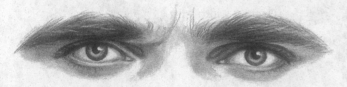

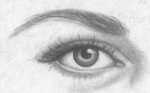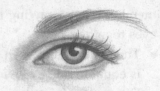

It is easy to see which eyes are male and which are female. Men's eyes differ mostly in the eyebrows. They are usually larger and closer to the eyes. See how these actually come down over the eyelids? Also, the eyelashes aren't as obvious.

Women's eyebrows usually have more of an arch to them. The eyelashes seem longer and darker.

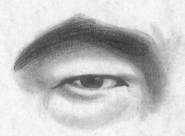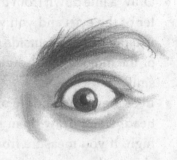

Eyes can tell you a lot about a person: race . . .

. . . emotion,

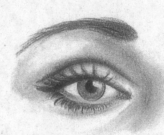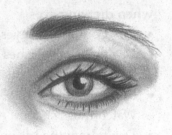

. . . age,

. . . beauty.

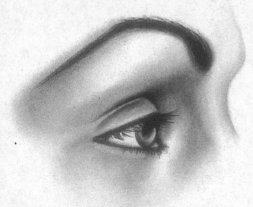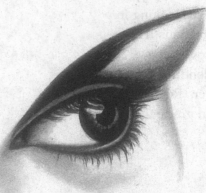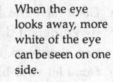

See how far the eye is recessed in the face when seen from this angle? The bridge of the nose blocks the other eye from your view. The iris no longer looks like a full circle, but is now a circle in perspective, which is called an ellipse.

When the eye looks away, more white of the eye can be seen on one side.

CHAPTER EIGHT

THE EARS

See how the ears fit together with the rest of the features? Like the other features, there is a formula to remember for their placement.

The *top* of the ear is directly across from the bottom of the eyebrow. The *bottom* of the ear is directly across from the bottom of the nose. When seen from the side, the ear is about in the middle, between the back of the head and the front of the eyes.

See the line I drew coming out from the eye? If you measure from the bottom of the chin up to this line, you will find that the eyes are really in the *middle* of your head! The distance from the top of the head down to the eyes is the same. On all of the portraits in this book, you will be able to see that this is true.

The eyes are in the middle of the head

This is what a drawn ear looks like. It has a lot of light and dark areas, doesn't it? It is also full of different shapes, some inside the other. But this is good, because it is easier to see it as puzzle pieces that way.

PUTTING THE EARS WHERE THEY BELONG

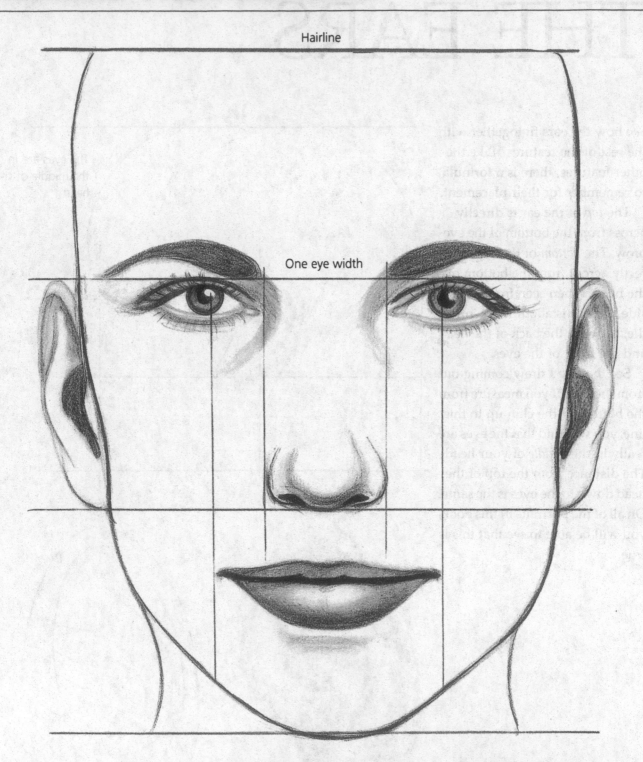

Hairline

One eye width

This illustration shows how the face area is divided into equal parts (from chin to hairline). The eyes and ears are in the middle section. In many portraits, the face is looking straight ahead, so the ears are at an angle—you can't really see them entirely.

This is how you will usually see the ear in a drawing. Most of it is covered by hair! Look through magazine pictures and draw as many different ears as you can find.

Note: Look closely at the ear-
rings. They look like tiny ver-
sions of the sphere exercise, don't
they?

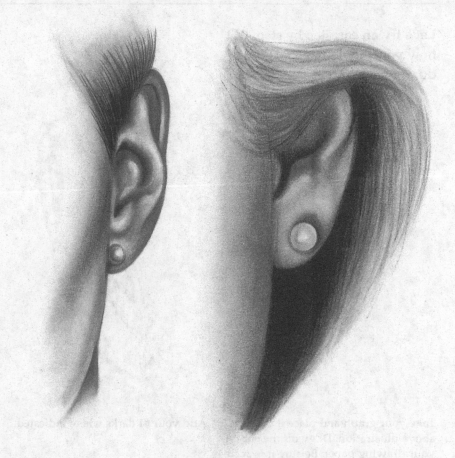

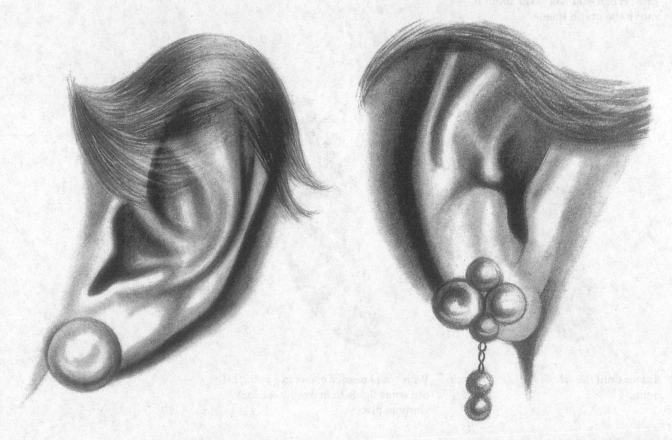

DRAWING THE EAR STEP BY STEP

Let's try an ear, step by step. By now you should have this procedure memorized!

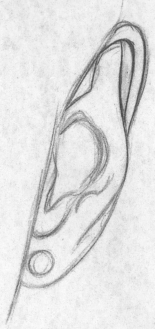

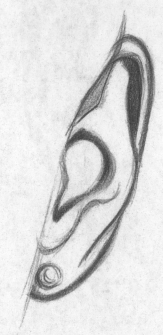

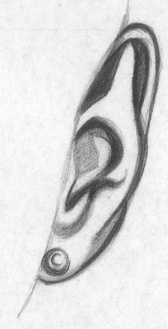

Take your graph and place it over the above illustration. Draw off the ear on your drawing paper. Be sure it is accurate. When you feel good about it, remove the graph lines.

Add your #1 darks where indicated.

Add your #2 areas.

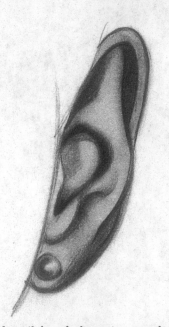

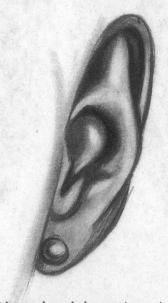

Blend until the whole ear is a gray halftone.

With your kneaded eraser in a point, lift out some lights to make the ear look shiny in places.

CHAPTER NINE

MAKING FACES

You should be very proud of yourself. If you have used the book step by step, you now know how to draw all the parts of the face. Congratulations! Let's take all we have learned so far and put it all together. Take the line drawing you did in chapter three, and step by step, *make it look real*!

First, double-check your line drawing. With all of the practice you have had, your skills have become more fine-tuned, and you might be able to improve on it. Check all of your shapes, and when you are happy with it, remove your graph.

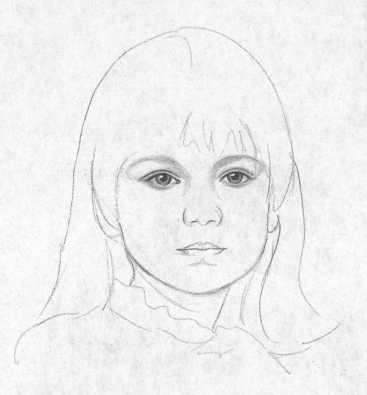

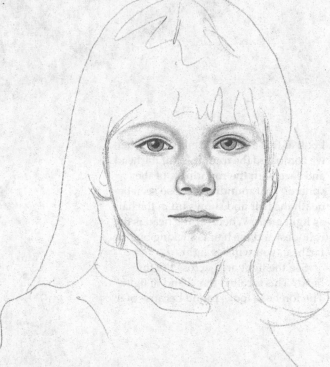

Refer to chapter seven on eyes and complete the eyes of the portrait. Work on them until you think it is the best you can do. Use your stencil for the iris and the pupil, and don't forget the catchlight. Look at the eyebrows. They are very light, with not much detail.

Move down and finish the nose and mouth as shown. Go back and review chapter five on noses and chapter six on mouths if you need to. Again, keep working on them until you are satisfied.

ADDING HAIR

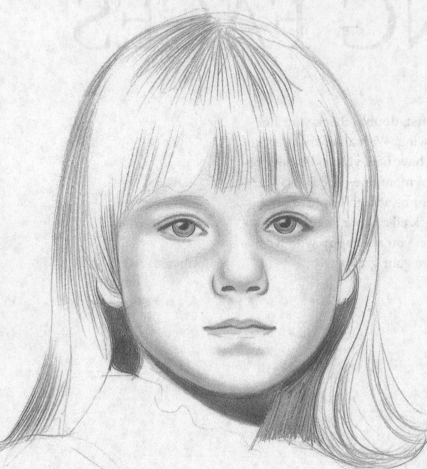

Shade the face and the cheeks. Refer to page 23 if you need help with the shadow placement. Remember the ball exercise. Add the dark areas next to the face, under the ears and on the neck.

The final detail will be the hair. Let's take some time to understand it. Like all of the other features, it has a formula to follow, in order to make it look real.

Look at this example. Remember when we compared the roundness of the head and face with the roundness of the sphere? That roundness is also seen beneath the hair and shows up in the hair as light areas. Wherever the head is the roundest and the hair is sticking out the farthest, you will see light.

See the light area across the forehead? This is called the "band of light." The forehead looks round because of it.

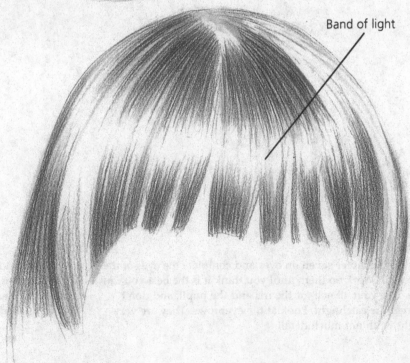

Band of light

DRAWING HAIR STEP BY STEP

People think that because hair is the last thing to draw, it is a quick finish. Well, it is the final touch, but it is far from being quick! Drawing hair so it looks real re- quires time and patience, but it is well worth the effort.

Follow along as I show you how to do the hair. I have left out the face, but you continue ahead on your drawing. You should at this time have the face fully drawn and blended.

Draw the hair as one large shape. Add some shading under the bangs. Hair creates shadows on the skin, so this will help keep the bright white of the paper from shining through.

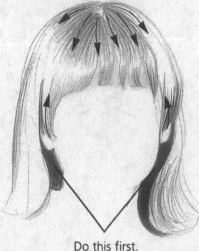

Do this first.

Apply quick pencil marks going in the direction of the arrows. See how it goes *down* from the top where the part is, and *up* from the bottom of the bangs? Keep applying the pencil lines until it starts to fill in. You can kind of see the "band of light" starting to form where the pencil lines don't quite meet. Keep your lines smooth; don't ever scribble.

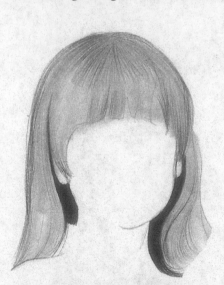

Blend everything out. Blend in the same direction that you applied the pencil strokes. Don't ever blend across!

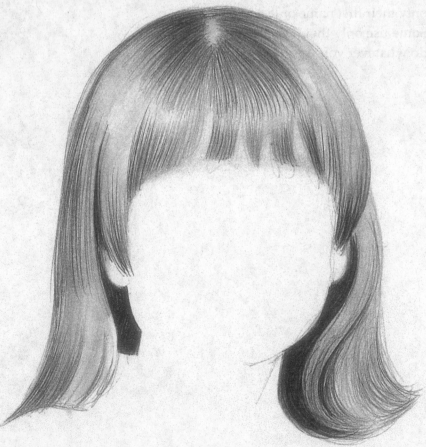

Darken the areas one more time. Use the same procedure as you did when you first applied your pencil lines.

PUTTING IT ALL TOGETHER

Shelly's Portrait

Well, here it is! The final product. I added a little bit of the shirt collar to help make it look real and signed the artwork. You do not have to include all of the clothing. You are not just copying a photograph. By adding some things, changing some things, and leaving some things out, you are making it your own creation, a true piece of art.

Always sign your artwork when you are finished. You don't have to sign every practice thing you do, but anytime you complete an entire portrait, you should finish it off with your personal signature. Some people use only their first name or last name. Some use only their initials. You do whatever you want. Have fun!

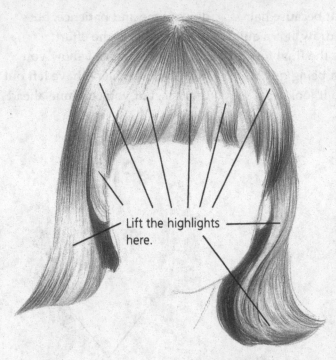

Lift the highlights here.

Take your kneaded eraser and create a "razor edge": Flatten the eraser between your thumb and finger to create a long, flat edge. Using quick strokes, pull out the highlights in the hair where I have indicated. You will have to reshape your eraser's edge with every stroke. If the marks don't always look great, you can go back and forth, adding darks and lifting lights.

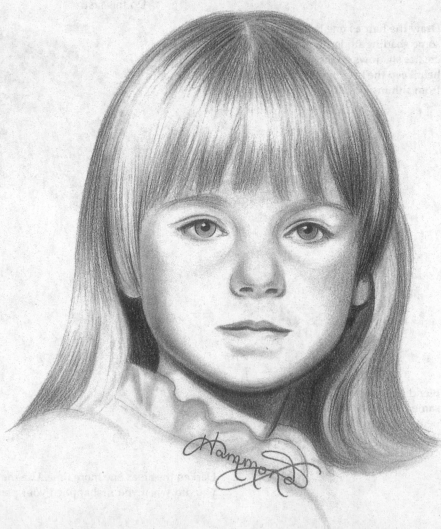

Shelly Ann, age 6
9" × 12", pencil on Bristol

DRAWING HAIRSTYLES

People are pretty similar as far as facial features go. Even though we are all different and have different looks about us, the basic details of our eyes, nose and mouth are very much alike. What really sets us all apart is our hair. There are so many different colors, cuts and styles, that it is impossible to include them all. On the following pages, I have tried to give you enough information to help you draw the most common types of hairstyles. Soon, with enough practice, you will see that any hairstyle can be drawn if you follow the right procedure.

This looks like a sphere with hair!

MORE HAIRSTYLES

These examples will give you more practice with different styles and hair colors. Study each carefully. See where you can identify the areas that have been drawn with a tortillion. Where is it drawn with the pencil? Where have I used the kneaded eraser?

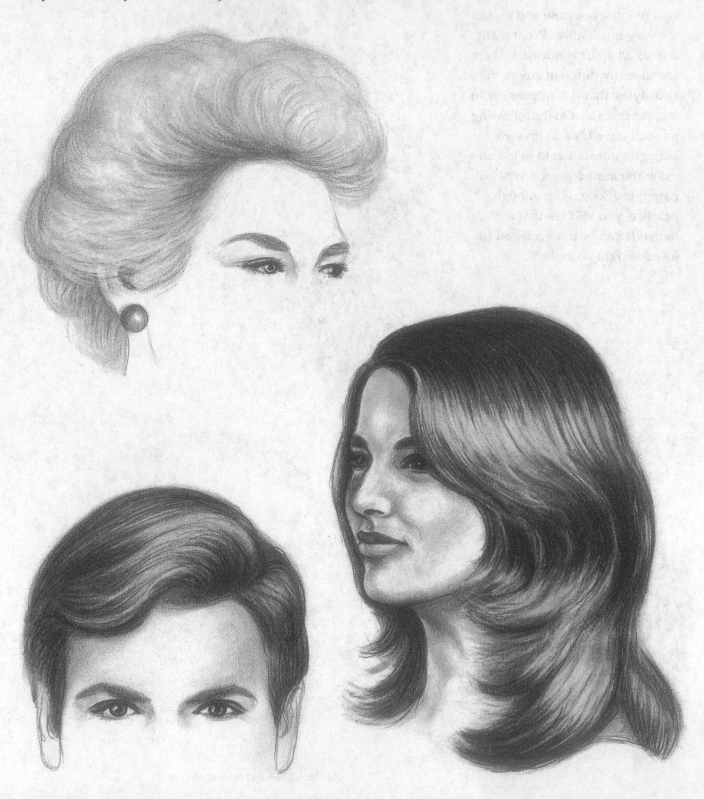

DRAWING CURLY HAIR

Curly hair can be fun to draw. Since all hair should be drawn in the direction of the hair's growth, curly hair is really just a bunch of little circular pencil marks. Try your hand at this short, fuzzy hairstyle. It's not as hard as it looks.

Start with a basic outline.

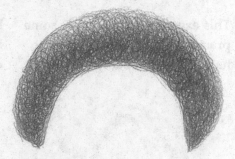

Fill in the shape with tight circular pencil lines until it fills in. Keep it lighter toward the outside edge.

Lighter on the outside edges.

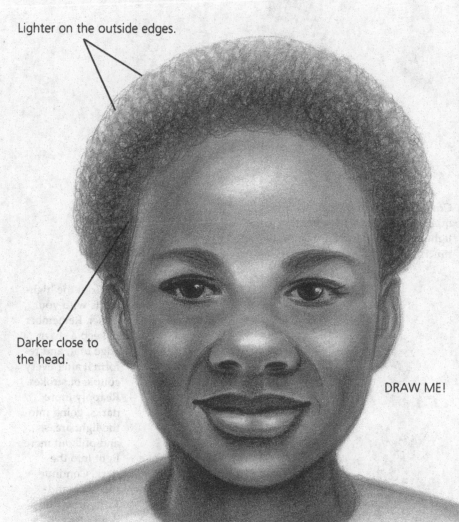

Darker close to the head.

DRAW ME!

Blend it out using the same circular motion.

Put your kneaded eraser into a *point* this time and use a "dabbing" motion to lift out light areas. Keep the light on the outside edge and reapply some darkness to the area closer to the head.

Use circular, squiggly lines.

For fun, take a small graph and draw this person. For even more of a challenge, try to draw the other hairstyles, and taking the skills you now have for drawing people, finish their faces.

LONG, STRAIGHT HAIR

This exercise will give you some practice drawing long, straight hair. This is probably the easiest hairstyle to draw; because of its long strokes, the hair direction is easy to establish.

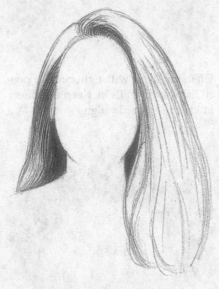

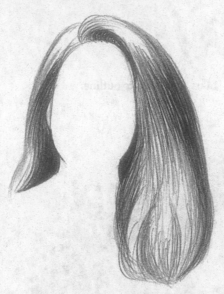

Start with your basic outline and fill in the dark areas beside the neck. Start to fill in the dark strokes on the left side and above the forehead. Watch for the direction the hair is growing.

Continue to fill in the hair with very quick, long strokes. Pay attention to the light areas and don't fill them in too much.

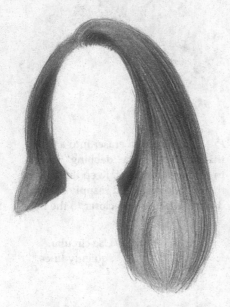

Blend out the whole thing to give it a soft, smooth look.

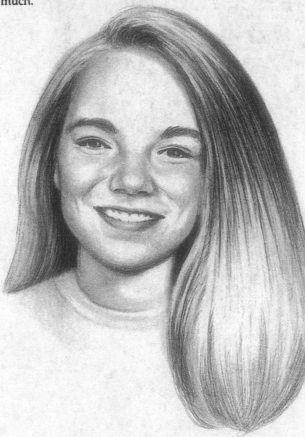

Pull out the highlights with your eraser. Remember to keep a sharp edge to it, and reform it after every couple of strokes. Reapply more darks, going into the light areas, and pull out more light into the dark. Continue this back-and-forth procedure until you get the look you like.

FROM THE TOP

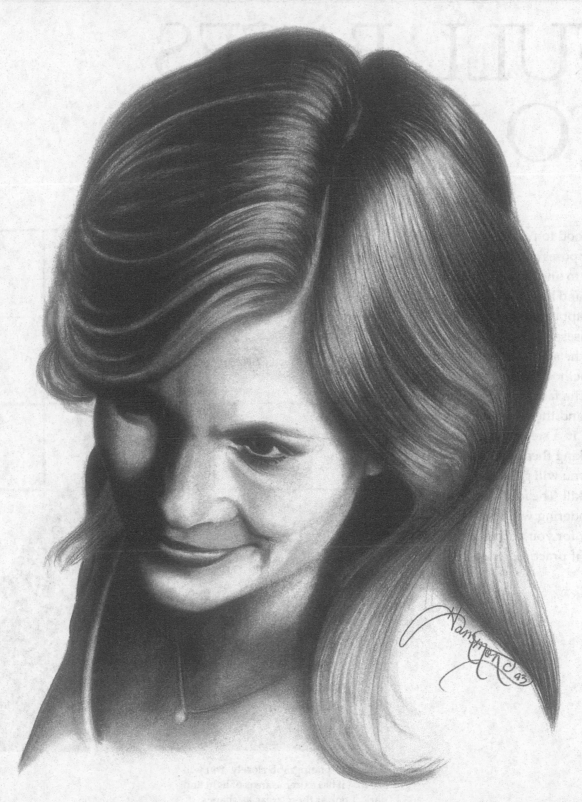

The top view of this portrait gives you the opportunity to see the highlights of the hair in a different way. See how the "part" shows up light next to the dark shadows? The band of light clearly shows where the hair is curving, since light always shows up on the places that protrude. The highlights that have been lifted give you the illusion of hair shine and hair direction.

CHAPTER TEN

FULL FACES TO DRAW

It is good to practice as many different poses as possible so you can begin to understand the facial features and how these poses change their appearance. The next four exercises will give you practice with the step-by-step procedure, the method that will *make it look real*! The face will be presented first, and then the hair will be given in a step-by-step manner. By taking these projects one by one, you will gain a lot of practice and skill. The four-step procedure of rendering will start to become easier for you and will become habit if practiced enough.

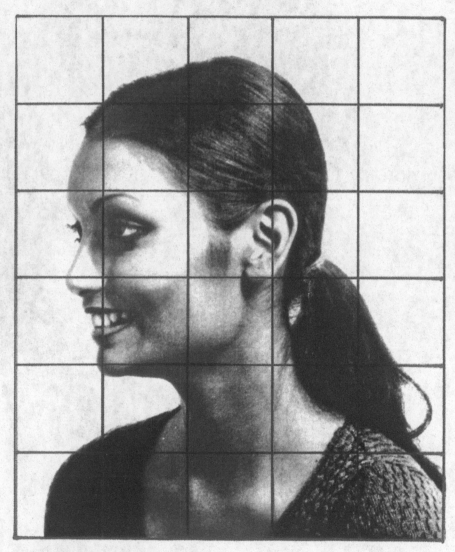

Study this photograph closely. You will see that it has extreme areas of light and dark. Look at these areas as shapes. It will help you place things within your graph.

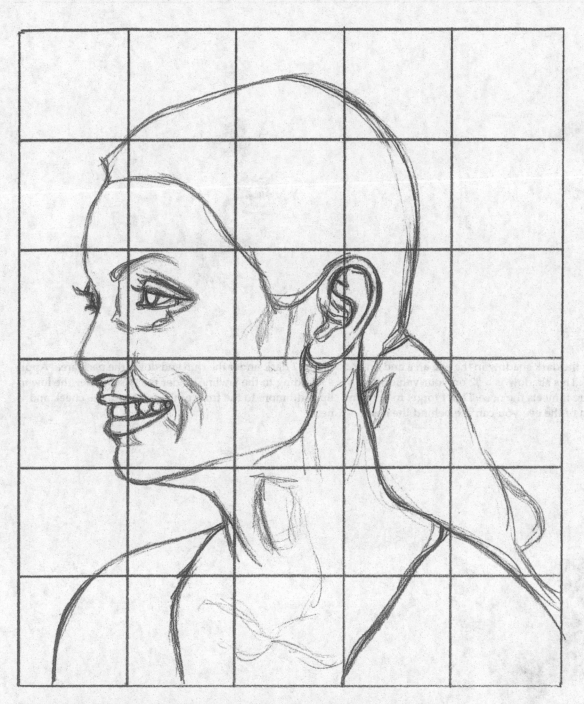

After lightly drawing a graph on your drawing paper, begin to draw the profile one box at a time. Can you see how I drew in the shadow areas as shapes? I know this looks funny, but it helps you keep things in the right place. Take your time and strive for accuracy. Be especially careful when drawing in the teeth. It is easy to get these off in their shape, and it will change the likeness if they are drawn wrong. When you are sure your drawing is as accurate as you can get it, erase the graph, and continue on to the next page.

DRAWING A PROFILE STEP BY STEP

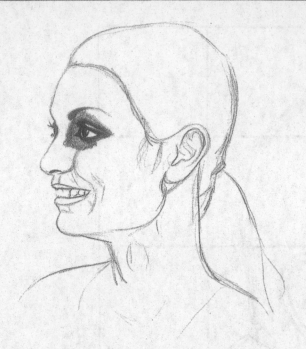

Begin by placing the dark shadow in the eye area and drawing the eye itself. This shadow is a #2 on your value scale, a little darker where it meets the nose. Don't forget to draw in the small portion of the eye you can see behind the nose.

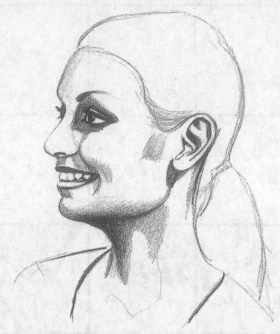

Place #2 dark under the chin and down the neck area. Apply #3 shading to the jawline, under the nose, under the lower lip. Add more to the front of the forehead, the cheek and neck.

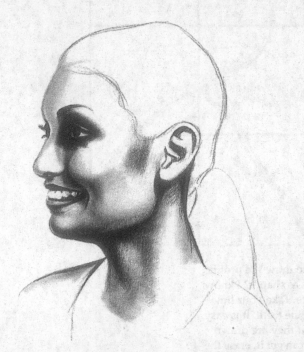

Now for the hair. See the hair as one big shape.

Blend from dark to light with your tortillion to give the illusion of smooth skin. Be sure your blending is smooth and even. This is the time to look for reflected light that is very subtle but extremely important. Reflected light is what makes things look rounded.

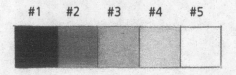

#1	#2	#3	#4	#5

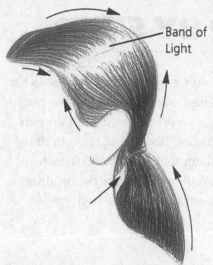

Band of Light

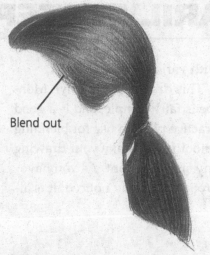

Blend out

Apply the darkness of the hair. Draw following the hair's direction. Take your strokes dark into light, leaving the "band of light." Keep filling until you achieve the right amount of darkness to give the illusion of dark brown hair. This is between a #1 and a #2 on the value scale.

Blend the whole thing out to make it smooth.

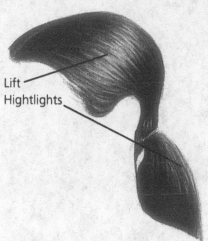

Lift Hightlights

Lift the highlights out with your kneaded eraser. Be sure to keep a sharp edge on the eraser. Add and subtract lights and darks until you get the look you want.

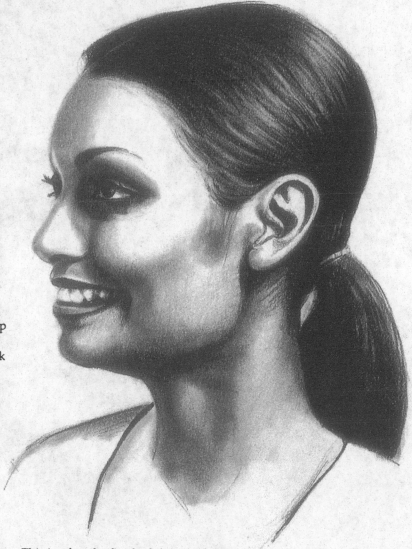

This is what the finished drawing looks like.

DRAWING MARILYN STEP BY STEP

Practice is the only way to get better and better! If you have done the assignments in the book, you now have tackled everything you need to know to make it look real! The following projects are designed to give you more practice,

with various types of looks.

This drawing of Marilyn Monroe is fairly simple, and is a good practice piece to use for blending smooth skin. Make your drawing any size you want. As you have probably already noticed, it is al-

ways easier to draw things on the large side. The step-by-step examples were reduced to fit on two pages. You do not have to draw them that small. Your 1-inch graph placed over the original portrait would be best.

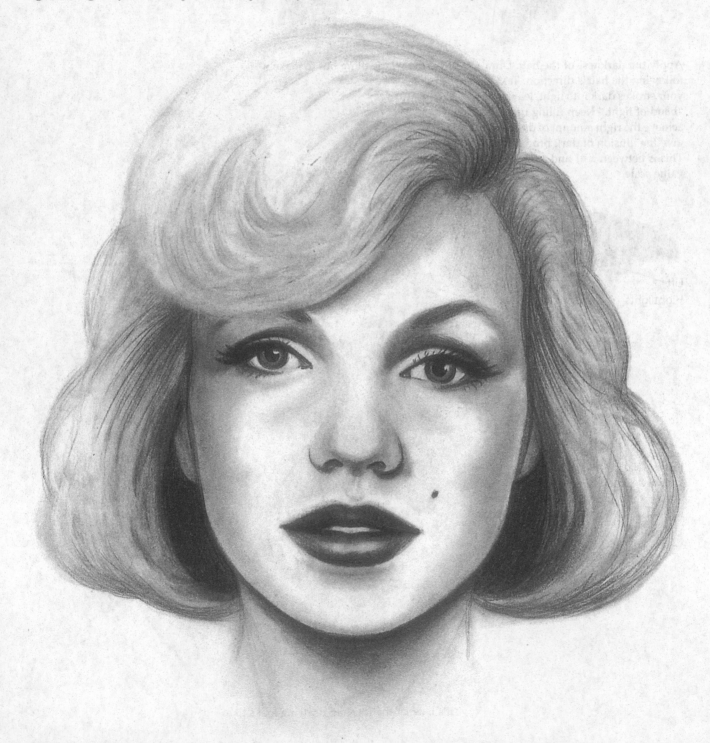

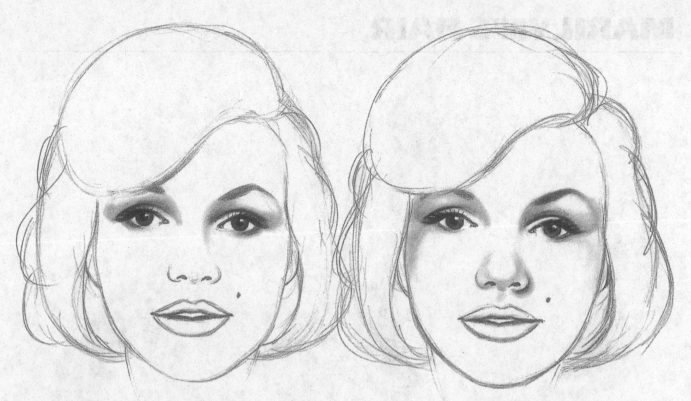

After you have completed your accurate line drawing and erased your graph, begin with the eyes.

Blend down the sides of the cheeks and render the nose. Refer back to the nose chapter if you need to.

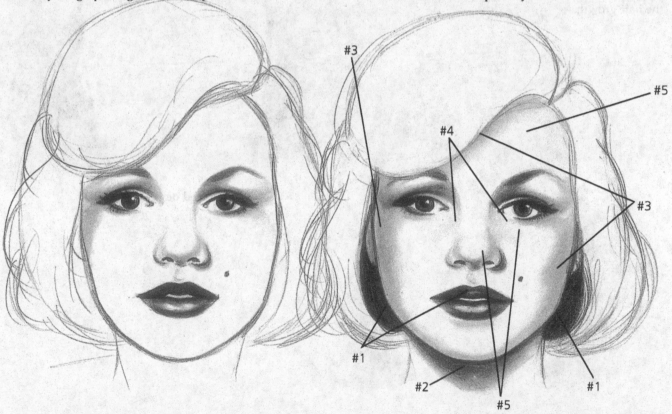

Apply the tone to the lips and blend. Lift the highlight on the lower lip for shine.

Blend the areas around the face. Apply the shadow under the chin, on the neck. Place some shading under the hair on the forehead, beside the face and under the ears.

MARILYN'S HAIR

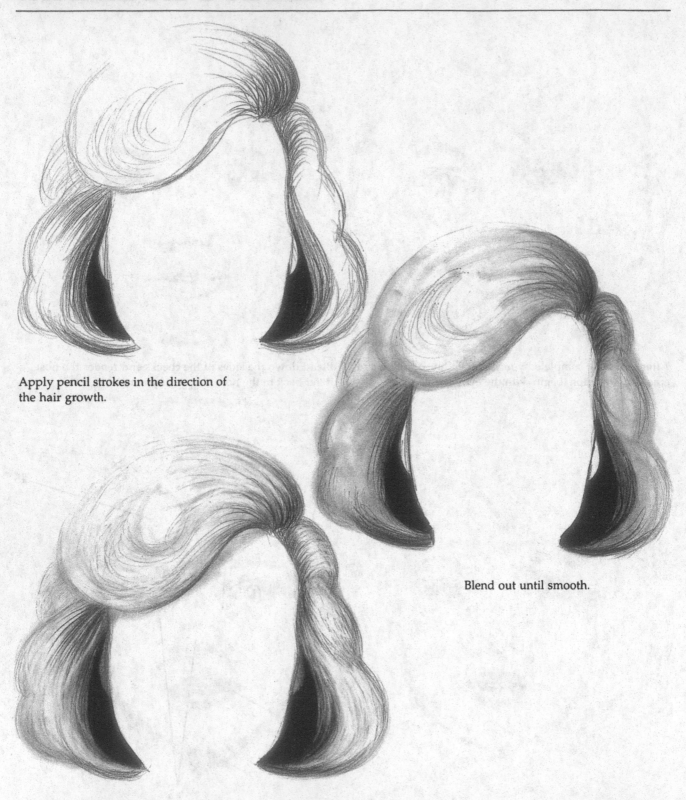

Apply pencil strokes in the direction of the hair growth.

Blend out until smooth.

Pull out highlights. Reapply darks, subtract lights. Go back and forth until you are happy with the look

GEORGE WASHINGTON

This portrait has many of the same details as the one before, but this drawing has much darker shadows. See how the shadow cuts across the neckline? Take your 1-inch graph and develop an accurate line drawing. When you are satisfied with its accuracy, remove the graph and continue on to the next page.

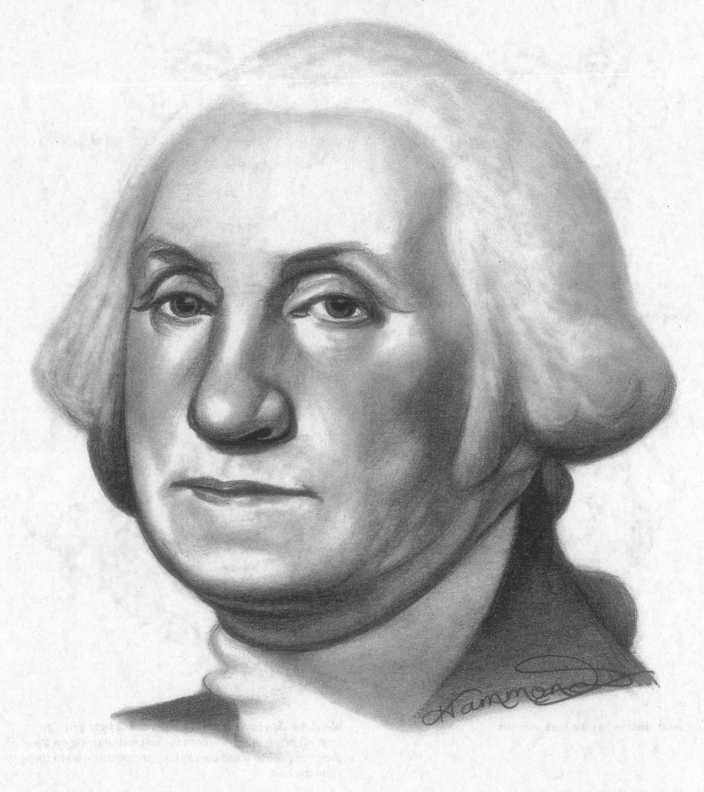

DRAWING GEORGE STEP BY STEP

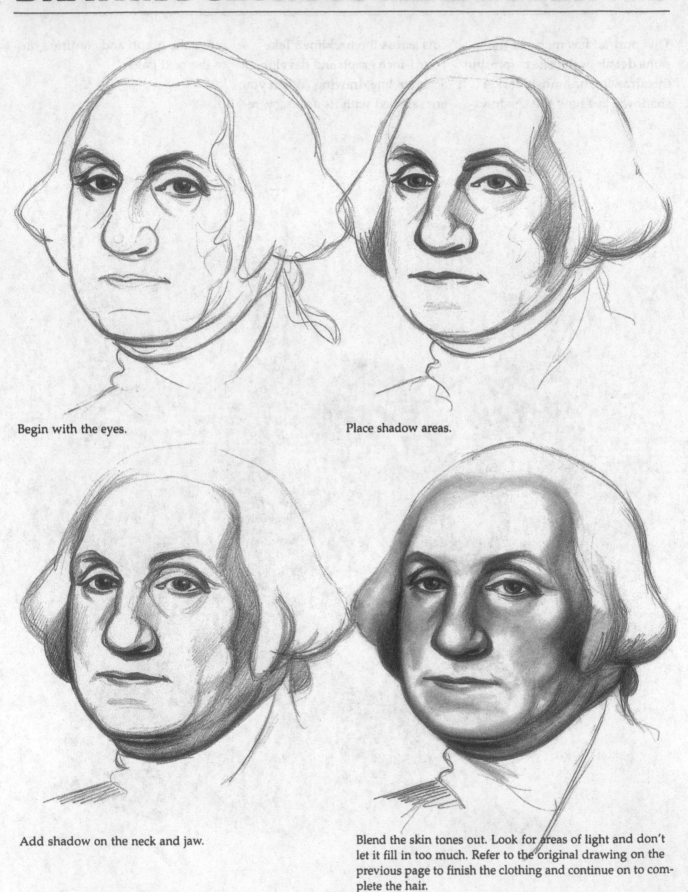

Begin with the eyes.

Place shadow areas.

Add shadow on the neck and jaw.

Blend the skin tones out. Look for areas of light and don't let it fill in too much. Refer to the original drawing on the previous page to finish the clothing and continue on to complete the hair.

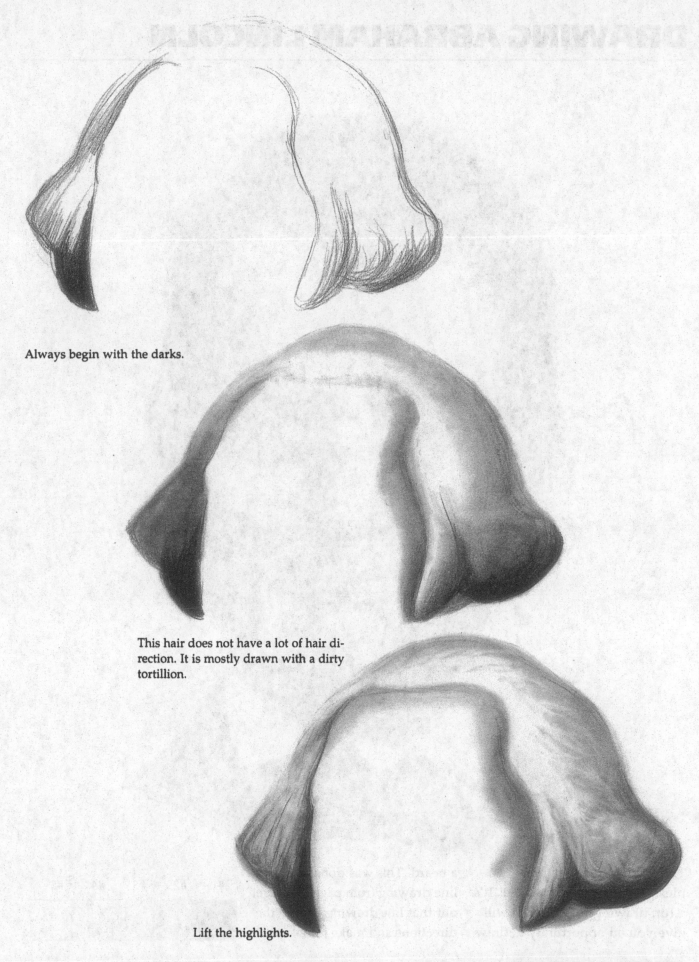

Always begin with the darks.

This hair does not have a lot of hair direction. It is mostly drawn with a dirty tortillion.

Lift the highlights.

DRAWING ABRAHAM LINCOLN

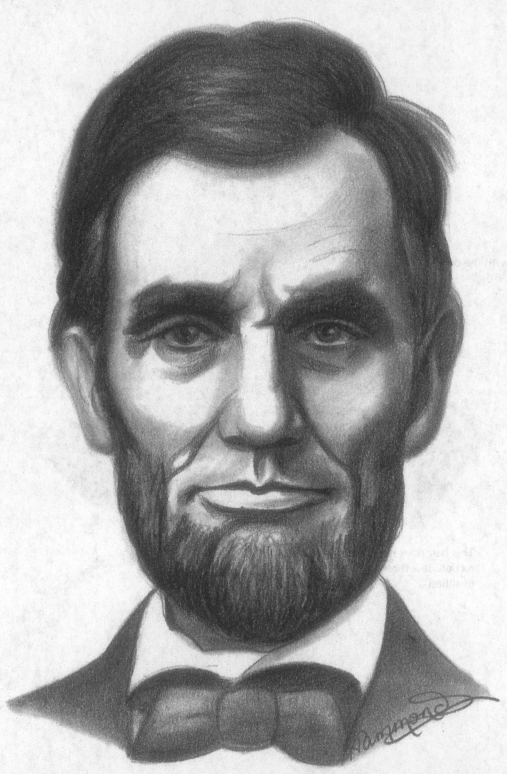

This drawing is even more complex, due to its extreme darks. It's a fun drawing to do, and it will give you an opportunity to draw a beard. This was done using the line drawing from page 18. So get out that line drawing, follow the directions and make it look real!

#1	#2	#3	#4	#5

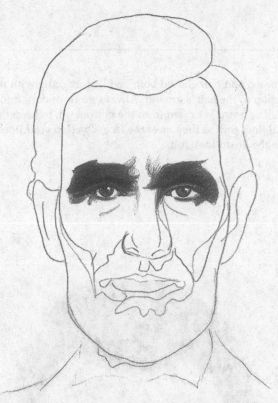

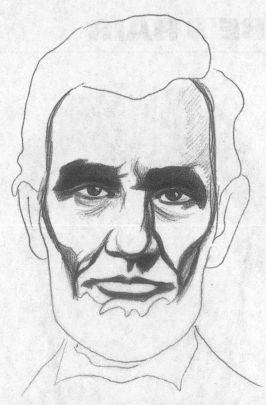

Begin with the eyes. Notice how dark and shadowed they are. These are #1 and #2 on your value scale.

Continue placing the dark areas (#2 and #3 on the scale) along the cheek areas, the side of the nose, under the nose, the upper lip, and below the bottom lip. There is some light shading (#3) along the right side of the forehead and under the eyes.

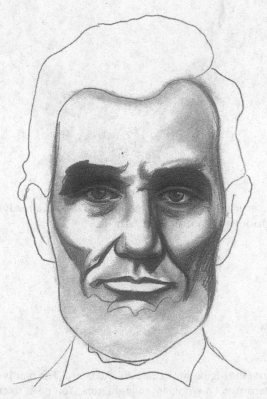

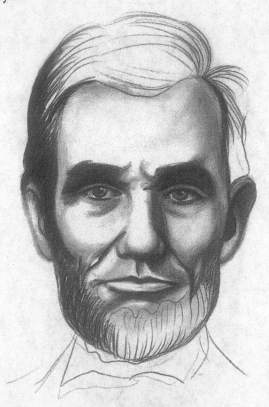

Blend your skin tones until smooth. Take a dirty tortillion into the beard area and blend out to a halftone. This will give you a foundation to build the beard on.

A beard is very much like drawing the hair on the head, only it is shorter. Use quick strokes to start filling the beard.

ABE'S HAIR

The beard and hair should both be filled in going with the direction of the hair's growth. Always go from dark into light. The beard is drawn from the bottom up, to keep the pencil lines thin as they meet the face. Overlap your lines to make the beard look full.

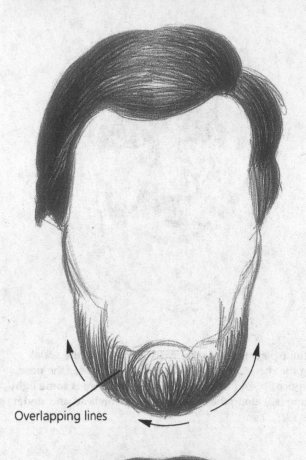

Overlapping lines

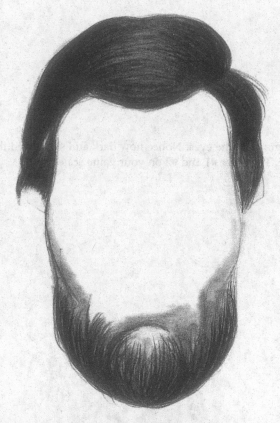

Blend everything out until smooth. You should already have the shadows blended on the face.

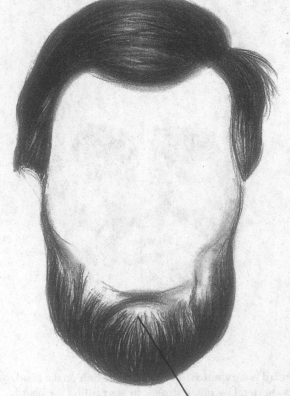

Overlapping highlights and pencil lines

Pull out the highlights in the hair and beard. The hair is dark, so there aren't a whole lot of highlights. You need to create texture with your pencil and eraser in the beard. This is done by overlapping pencil lines and overlapping your light areas as you lift them out.

MORE EASY FACES TO DRAW

The following pages will provide you with three photographs to draw from. I have graded them as *Easy, Medium* and *Advanced*. A graph has been drawn on each one, and a graph with a line drawing has been provided to help you with your outline. Start with the easy one and move on only when you feel you are ready for the next one. If some of them seem too difficult right now, wait. Practice from magazine pictures, draw just individual features for a while, or practice any areas that you feel need more work. You have plenty of time, and your skills will only get better and better. But remember this: You will only be as good as the amount of *practice* you put into it!

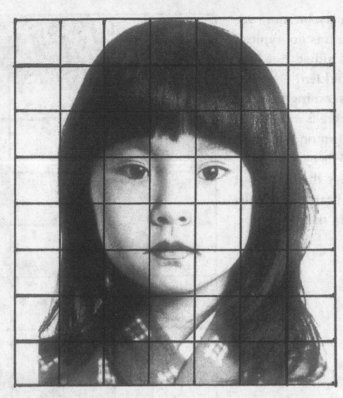

This is a fairly easy one to do, because it has a very simple expression. The shading is simple; you see it mostly on the left. The light is coming from the right, and the "band of light" is much lighter on the right.

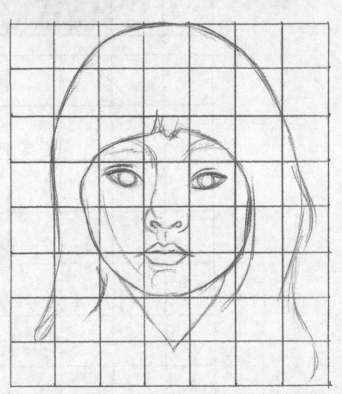

Using the graphed outline to help you with the shapes, see if you can shade this one on your own. Refer back to the previous little girl portrait on page 45 if you need to see the formula. It is very similar. The hair is just a lot darker on this one.

MEDIUM

This photograph is a bit more advanced. His mouth is not typical and needs to be studied. See how the lower lip is hidden? Once again, the light is coming from the right side, but there is a bright area of *reflected light* on the left side of his face. His eyes are so dark, you can't see the pupil, but be sure to get that catchlight in the right place (not in the middle).

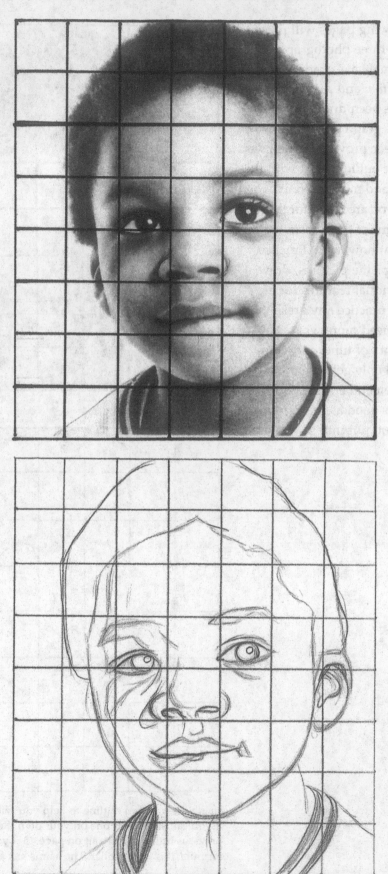

ADVANCED

This photograph is much more advanced. The turn of the face is what makes this more of a challenge. Here is a list of things you should look for when doing this one.

1. Because the face is turned to the right, you will see *less* of the face on that side. Also you will see less of the right side of the mouth and eyes, and *none* of the right side of the nose.

2. See the shadow areas on the left side of the face? Look closer and you will see an edge of reflected light between them, running along the jawline.

3. There are light hairs, wispy ones, that go over the dark areas of the face and cut across the ear. You can also see some on the shadows of the neck. These are pulled out with your kneaded eraser with the razor-edge technique (see page 48).

4. You can hardly see her eyebrows. Use your tortillion for them.

Try to follow the same procedure that you have used before. See everything as a shape. If an area seems confusing, look at it a different way, like a puzzle. Turn it upside down and look at it that way. Most of all, take your time!

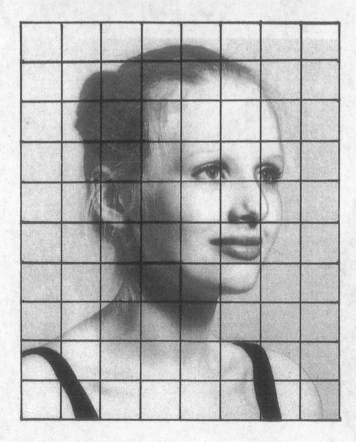

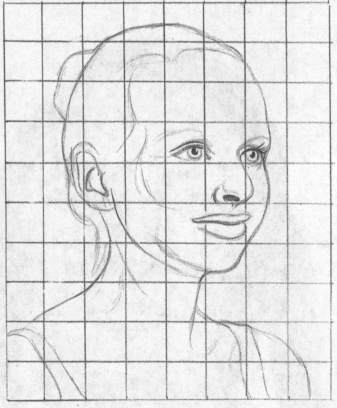

SHOWING ETHNIC DIFFERENCES

Every person has their own special look. That is why portrait drawing can be so rewarding. But every race of human being has their own characteristics, too. These four examples show how different we all are.

The bone structure and face shape is different in each one of these. Also, the noses and lips change from one to another. Look at the eyes. Can you see how they vary in not only their shape but also in their color? And each one of these men has a different type of hair.

Have fun looking through books and magazines and really study the differences in the ap-

pearance of people. It can be fascinating. Use your graphs to practice drawing them. Practice every day and you will become a wonderful portrait artist!

The four basic varieties of humans:

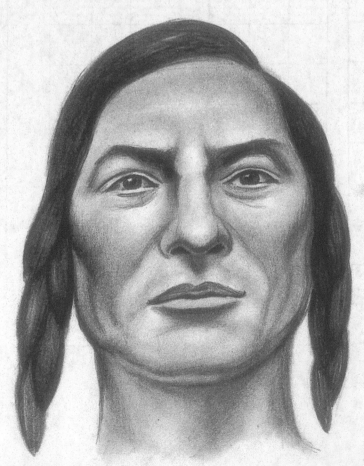

White, Caucasian or European.

American Indian.

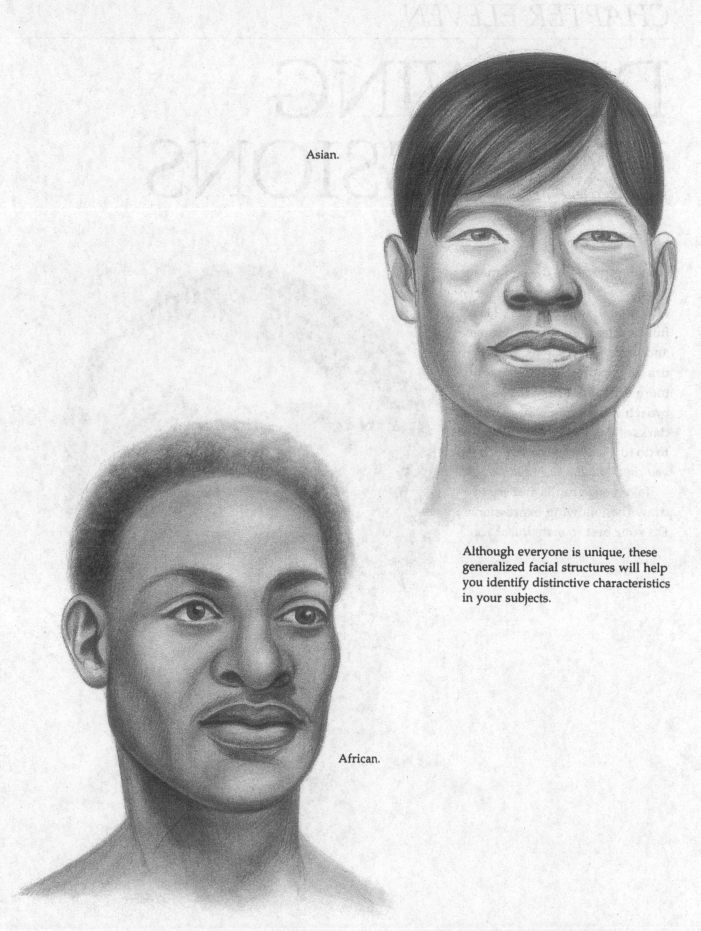

Asian.

Although everyone is unique, these generalized facial structures will help you identify distinctive characteristics in your subjects.

African.

DRAWING EXPRESSIONS

Drawing portraits doesn't mean you have to always draw a serious or smiling expression. Have fun finding photos with strange and funny expressions. Although drawing expressions may seem more difficult at first, if you approach it the same way—shapes, darks and lights—you will be able to do it! *If you draw the shapes right, you can draw the face right.*

Take your graphs and try to draw the following expressions. Do your best to *make it look real*!

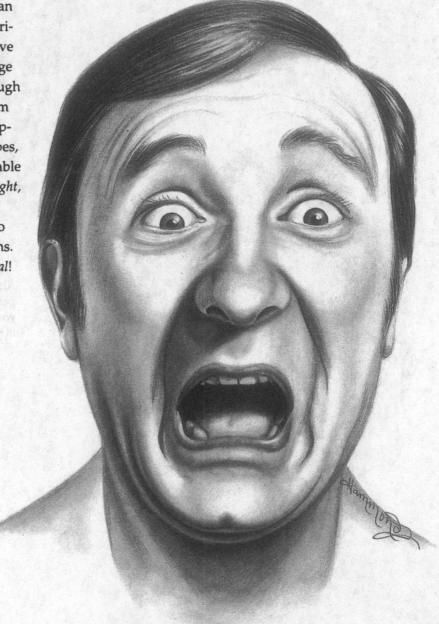

ONE FACE, TWO EXPRESSIONS

This is an example of how different faces look, depending on mood and expression. It almost looks as if this were two different people. The expression actually changes the shape of the face by the way the muscles are being used.

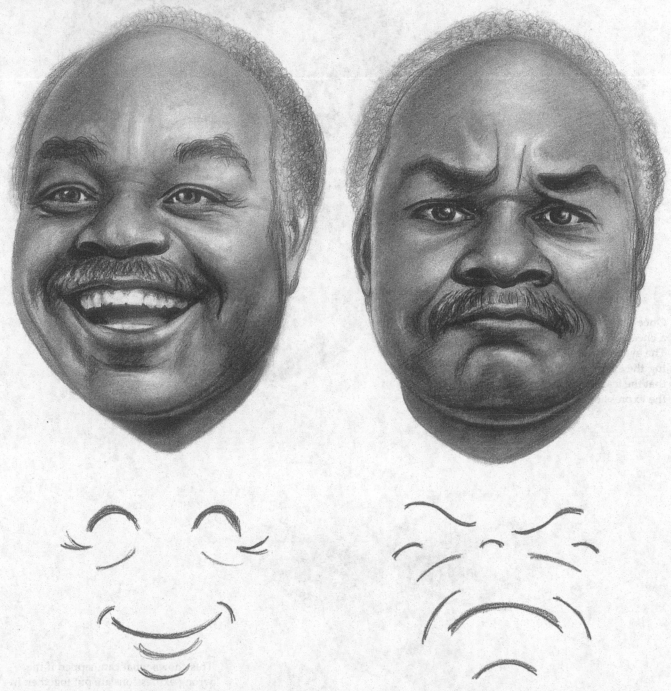

On a smiling, happy face, all of the lines of the face take an upward direction.

On a sad face, the lines of the face take a downward direction.

GRINNING

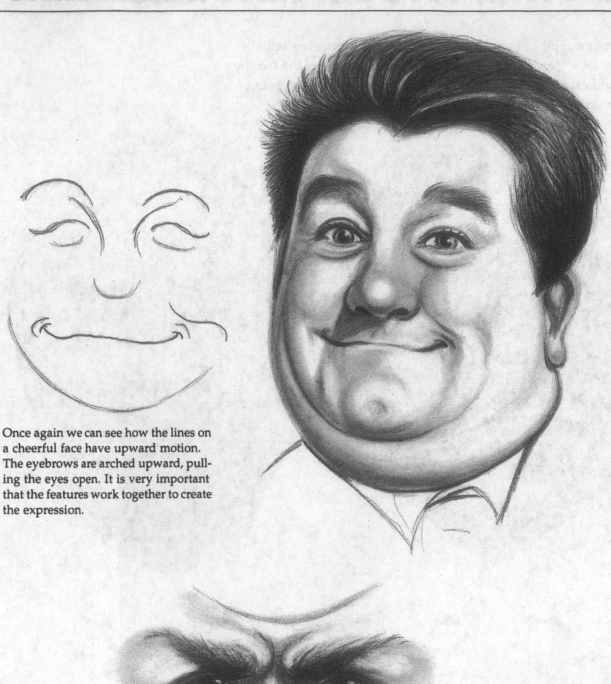

Once again we can see how the lines on a cheerful face have upward motion. The eyebrows are arched upward, pulling the eyes open. It is very important that the features work together to create the expression.

This shows what can happen if the wrong expressions are put together. Instead of arching the eyebrows *up*, this time I made them come *down*. The smile and the nose remained the same, but can you see how much the look has changed? It gives the man a devilish look instead of a happy grin.

CRYING

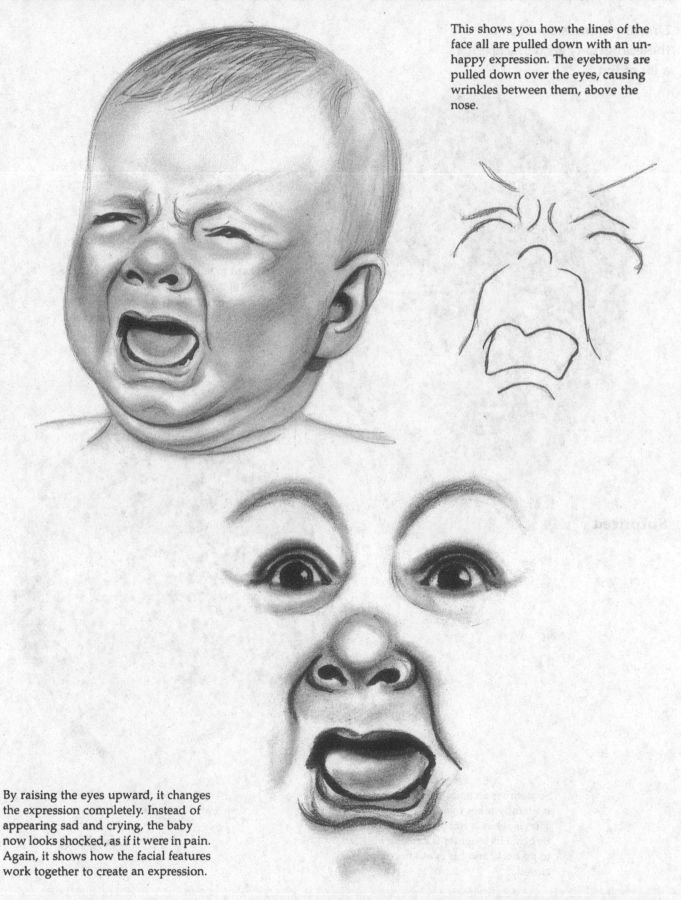

This shows you how the lines of the face all are pulled down with an unhappy expression. The eyebrows are pulled down over the eyes, causing wrinkles between them, above the nose.

By raising the eyes upward, it changes the expression completely. Instead of appearing sad and crying, the baby now looks shocked, as if it were in pain. Again, it shows how the facial features work together to create an expression.

VERY EXPRESSIVE FACES

Drawing expressions such as these is not only good practice, it's a lot of fun.

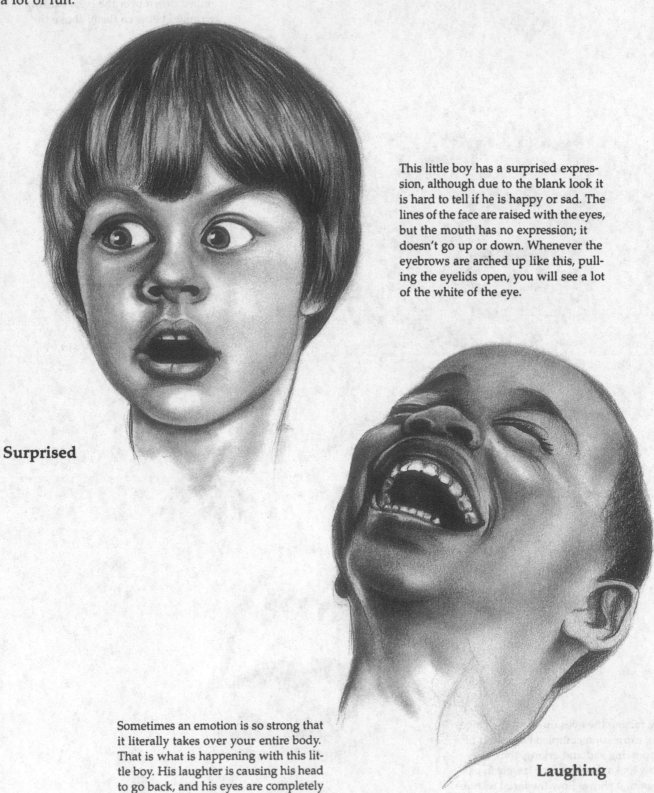

This little boy has a surprised expression, although due to the blank look it is hard to tell if he is happy or sad. The lines of the face are raised with the eyes, but the mouth has no expression; it doesn't go up or down. Whenever the eyebrows are arched up like this, pulling the eyelids open, you will see a lot of the white of the eye.

Surprised

Sometimes an emotion is so strong that it literally takes over your entire body. That is what is happening with this little boy. His laughter is causing his head to go back, and his eyes are completely closed.

Laughing

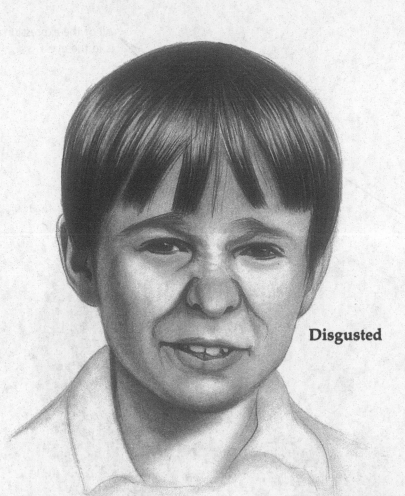

Disgusted

Note: For a real challenge and a good way to check your skills, go through magazine pictures and find a full-page face that has been printed in black and white. Cut the picture in half, right down the middle. Glue half of it to a piece of your drawing paper, leaving enough room on the paper for the other half. Now *draw* the other half and see if you can make it match the printed side! (Use a graph to help with shapes.)

Once again, we can see how important the eyebrows are to the overall look. The mouth plays an important part, too. On this little boy, you can clearly see that he isn't too happy about something. Look and see how the nose is wrinkled up between the eyes.

On this example the nose is wrinkled between the eyes also, but the eyebrows come down, causing an angry look. On the example of the little boy above, the eyebrows angle up in the middle, so although he doesn't look pleased, he does not look angry.

Angry

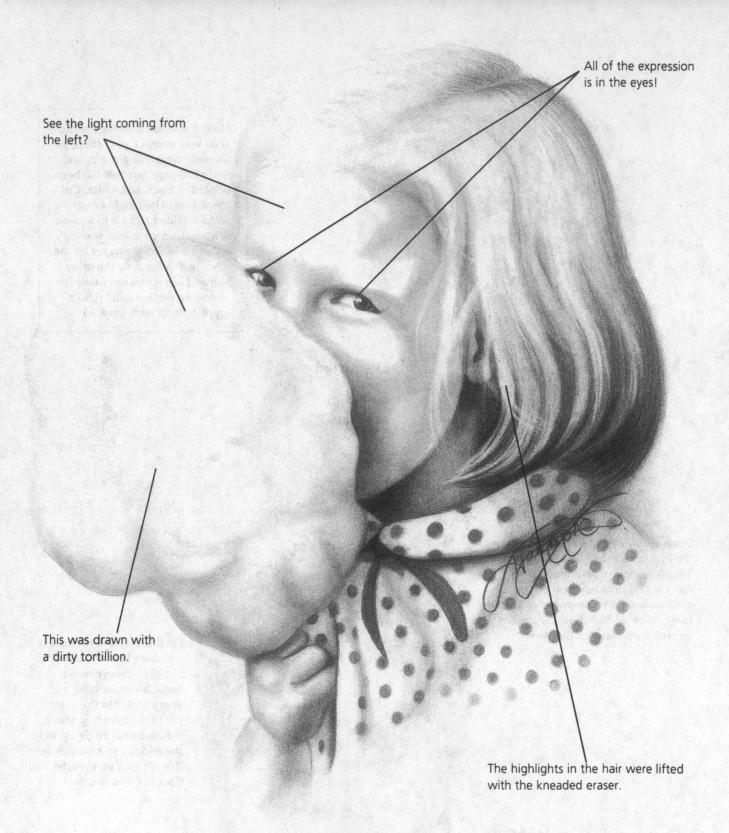

See the light coming from the left?

All of the expression is in the eyes!

This was drawn with a dirty tortillion.

The highlights in the hair were lifted with the kneaded eraser.

"Polly" at the Fair
9" × 12", pencil on smooth Bristol

Sometimes the entire face does not have to be visible to show a lot of expression. This was a fun one to draw! A big part of it, especially the cotton candy, was drawn with a dirty tortillion. This is a good drawing to practice your blending with.

CONCLUSION

You now have all the knowledge necessary to make your drawings look real! With every hour that you practice, you will become better. Practice every day. Set aside a certain time just for you and your art. Draw from snapshots or magazine pictures. Practice entire portraits and individual facial features. It doesn't really matter, as long as you're drawing.

You can now see that there is a definite procedure to follow. The more you draw, the more natural this procedure will become. Soon, you won't have to think about it quite as much; it will become second nature to you. Everything will suddenly become easier to draw, because you will be "seeing" it differently.

I hope you will find your work improving every day before your very eyes. Have fun, because from here on out, it only gets better. The only problem you will probably run into is not having enough time to work on all the projects you will be wanting to do. Grab your pencil and go for it! Get some paper and *MAKE IT LOOK REAL!*

INDEX